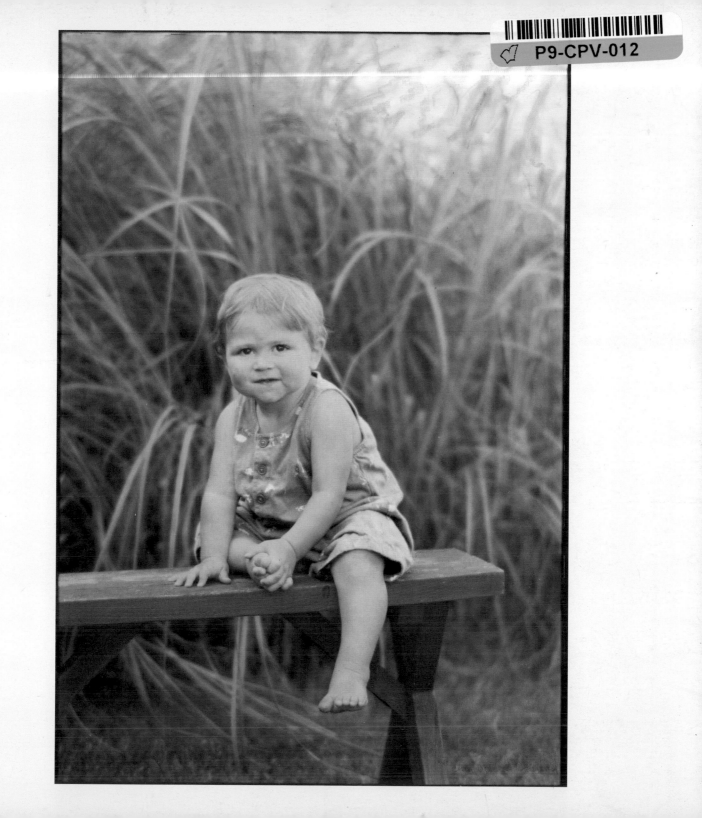

THE *Art* OF HANDPAINTING PHOTOGRAPHS

CHERYL MACHAT DORSKIND

AMPHOTO BOOKS
AN IMPRINT OF WATSON-GUPTILL PUBLICATIONS, NEW YORK

ACKNOWLEDGMENTS

I want to thank my husband, Glenn, for his love and skill, and his encouragement to fly. Thanks also goes to to my friend Pat Capon, for her publishing-world insights and major confidence building; to my enthusiastic father-in-law, Bob Dorskind, a loving and early collector; to my first client, Penny Sommer—another great confidence builder; to Alex Harsley, for his poignant insights and for my first show at the Fourth Street Photo Gallery; and to Diane Vahradian, for her professional sharing and loving support.

Thanks also to Robin Simmen at Amphoto, for her large vision and artistic tour guiding, and to my gifted editor, Alisa Palazzo, who fell in sync with my voice. And finally, thanks to my clients and their children, who beautifully grace the pages of this book.

Page 1: Griffin
Page 2: Kristin
Page 6: Nicole

Editorial concept by Robin Simmen
Project Editor: Alisa Palazzo
Designer: Areta Buk
Production Manager: Ellen Greene

Text and photographs copyright © 1998 Cheryl Machat Dorskind

First published in 1998 by Amphoto Books, an imprint of, Watson-Guptill Publications a division of BPI Communication, Inc., 770 Broadway, New York, NY 10003

Library of Congress Cataloging-in-Publication Data
Machat Dorskind, Cheryl.
 The art of handpainting photographs / Cheryl Machat Dorskind.
 p. cm.
 Includes bibliographical references and index.
 ISBN 0-8174-3310-4 (pbk.)
 1. Photographs—Coloring. 2. Photography, Handworked.
 3. Painting—Technique. I. Title.
 TR485.M23 1997
 771'.44—dc21 97-36327
 CIP

Printed in Italy

3 4 5 6 7 8 9 / 06 05 04 03 02 01

Permissions have generously been provided to use quotations from the following works: From *Henri Cartier-Bresson* (History of Photography Series, Aperture, 1976), reprinted by permission of Henri Cartier-Bresson. From *Interaction of Color* by Josef Albers (Yale University Press, 1963), reprinted by permission of The Josef and Anni Albers Foundation. From *Zen Mind, Beginner's Mind* by Shunryu Suzuki, reprinted by permission of Weatherhill. From pages 21–22 of *Vincent van Gogh* by Meyer Schapiro, published by Harry N. Abrams, Inc., New York, 1983. From *Milton Avery* (Strathcona, 1981), reprinted by permission of The Milton Avery Trust. From *Fabrications: Staged, Altered, and Appropriated Photographs* copyright © 1987 by Anne H. Hoy, reprinted by permission of Abbeville Press. From *Exploring Color* copyright © 1991 by Nita Leland, reprinted by permission of North Light Books, a division of F & W Publications, Inc. From page 106 of *On Photography* by Susan Sontag, copyright © 1973, 1974, 1977 by Susan Sontag, in the US and Canada reprinted by permission of Farrar, Straus & Giroux, Inc., and in the UK and Commonwealth published by Penguin UK and reprinted by permission of Frederick Warne & Co. From the Light Impressions Catalogue (January 1997), reprinted by permission of Light Impressions. Excerpt from "Little Gidding" in *Four Quartets* by T. S. Eliot, copyright © 1943 by T. S. Eliot and renewed 1971 by Esme Valerie Eliot, reprinted by permission of Harcourt Brace & Company (US) and Faber and Faber Ltd (English-language rights worldwide excluding US).

THIS BOOK IS DEDICATED TO MY HUSBAND GLENN,
THE LOVE OF MY LIFE AND MY BEST FRIEND

AND TO MY DELICIOUS DAUGHTERS NICOLE AND JOELLE,
MY PRECIOUS HEARTTHROBS

CONTENTS

PREFACE

\mathcal{R}etracing the past reminds me of a connect-the-dots picture. Everything seems so obvious and clear on completion; however, when you're in the midst of the puzzle, finding the next dot is a struggle. Although I pursued the idea of becoming a photographer, it was never really clear that this had been my path until I actually became one. Now, in retrospect, I remember many events that shaped my present life. I remember, for example, that when I was 16, I vacationed with my family in Acapulco, Mexico. I recall walking barefoot on the burning hot sand as the sun fell below the horizon. Brushstrokes of color caressed the sky. Mesmerized by the firecracker power of the pink, red, purple, and orange before me, I was determined to capture this heightened moment with my camera. Waiting the following evening, perched on a cliff, I composed the photograph that ignited my dream—to become a photographer.

I purchased my first "professional" camera—a Nikkormat NTN—the following year. It was an extravagant purchase, costing my entire life savings, much to the chagrin of my parents. A few years later, I purchased a second camera—a Nikon F2. Many of the photographs that you'll see in this book were recorded with these cameras.

During my college years, I was pragmatic as I prepared myself with survival skills, studying business administration and graduating with a B.S. in marketing. My dream of becoming a photographer slipped away and was temporarily overshadowed by the realities of the business world. Heeding my parents' stern warning that the competitive

ACAPULCO, MEXICO

The intense hues in the Acapulco sky inspired me to become a photographer.

nature of photography leads to an unstable lifestyle, I opted for a position as a product manager for a well-known record label. My years in the music industry were infused with contradiction. I was happy and sad constantly: happy because I'd achieved success, recognition, and status, but sad because I soon discovered that there was more to life than the next hit record. I felt alienated although I was constantly surrounded.

Ironically, while shopping at Bloomingdale's on a lunch break, I remembered my dream of becoming a photographer. I noticed handcolored photographs displayed in the home furnishings department and instantly recognized my calling as my years of painting, drawing, and photography alchemized in a flash.

At that time, there was little information available on the technique of handpainting, and what was available proved contradictory and frustrating. Determined, I experimented with photographic papers, artist's oil paints, and pencils. The learning process was often exasperating and expensive, but I persevered. In 1987, I had my first solo exhibition in New York City and have been included in over 40 shows since. I began teaching handpainted photography in 1993. My lesson plans developed into an outline for this book; the success of my many students further encouraged its publication.

Dive with me into the lush world of handpainted photography, and explore the abstract nature of people, places, and things. Working with shapes, tones, colors, and the magic of light, you can transform simple black-and-white images into unique photopaintings.

SELF-PORTRAIT,
TELEVISION

This black-and-white photograph is a perfect candidate for handpainting.

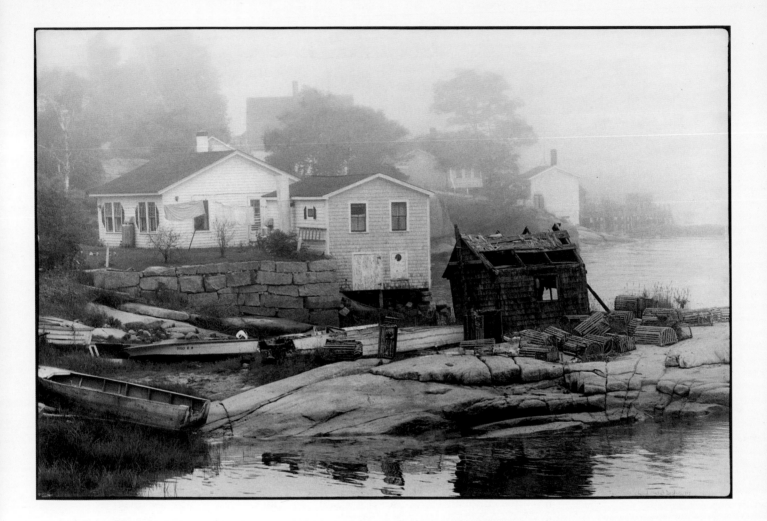

INTRODUCTION

*P*eople have been colorizing photographs for over a hundred years. The technique originated due to a desire to soften the realities that primitive photographs depicted. The public, once comfortable seeing themselves portrayed through a painter's romantic eye, was disturbed with the harshness of the daguerreotype. Painters were employed to embellish the photographs, typically adding color to cheeks, eyes, and hair. And so, the medium of handtinting or handcoloring was born.

During the last two decades, handcoloring has experienced a dramatic revival. Print advertising, greeting cards, and posters have all brought this art form into households worldwide. Almost all local card shops carry black-and-white photographs highlighted with vibrant color that draws attention to flowers, lips, or hats. Today, this type of enhancement is still referred to as handtinting, or handcoloring, and it describes the process of either highlighting a portion of a black-and-white photograph with color, or lightly washing color over the entire photograph.

The technique of *handpainting* photography takes the practice of handtinting one step further. The painterly execution is an equal part of the rendering, so handpainted images are paintings on paper. In this case, the paper happens to be a photograph. Some handpainters cover the tonal values of their photographs completely, using opaque paints and literally blocking out the photograph. Like an artist executing a preliminary sketch on a canvas with charcoal, the handpainter uses the photographic gray scale (of tones) in the image as a type of sketch. Other photographers, myself included, utilize the gray scale as a launching point from which the image is heightened by the painter's realm. Those underlying gray tones enable the paints to create a mystical and ethereal dialogue with the photograph, and also with the viewer.

This book will focus on the art of handpainting in this manner, and in fact, I often refer to my handpainted photographs as "photopaintings." The art of handpainting encompasses vision, meditation, creativity, and technique; I'll concentrate on technique and, hopefully, inspire the rest. I present the basics, including choosing film, photographs, paper, and paints; then explore the preparation process, color theory, and color application to different visual motifs; and, finally, cover presentation and future projects.

MISTY HARBOR VIEW

During regular travels to Maine, I often journeyed off the beaten path into the rugged back roads to make photographs. Here, the subtle use of vibrant color enhances the raw environment captured in the image.

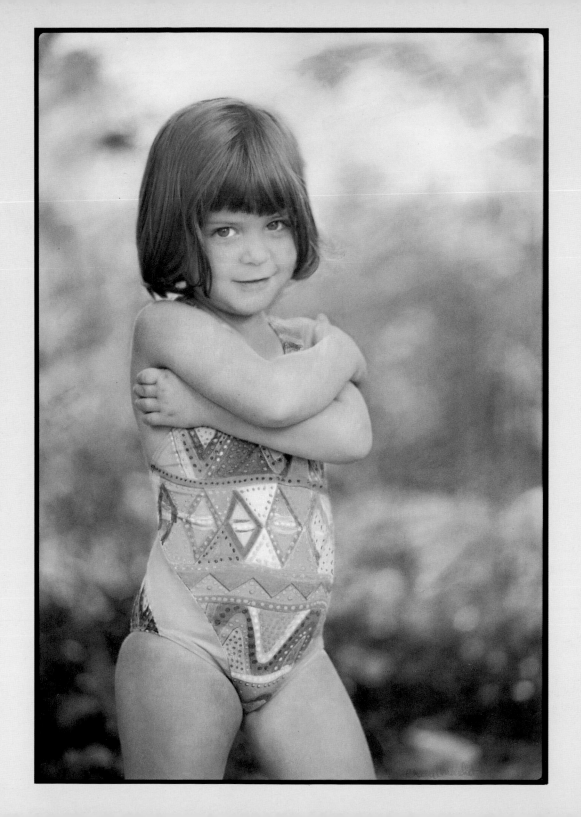

SELECTING A GOOD PHOTOGRAPHIC PRINT

For me the camera is a sketchbook, an instrument of intuition and spontaneity. In order to "give meaning" to the world, one has to feel oneself involved in what he frames through the viewfinder. This attitude requires concentration, a discipline of mind, sensitivity, and a sense of geometry.
—*Henri Cartier-Bresson*

The key to making a well-executed handpainted photograph is choosing a quality image. Handpainting cannot transform inferior work, but it will take a poetic and inspired photograph to a higher realm. So let's explore what to photograph with the intention of handpainting the finished image. Subject matter and composition are what we'll focus on first; then I'll discuss film, paper, and development more specifically.

To select a photograph for handpainting, choose a subject that's meaningful to you. It can be a portrait, landscape, cityscape, still life, interior scene, or abstract composition, but it must be meaningful on a spiritual or emotional level. The photographs on this page are good examples of images that exhibit the emotional hook necessary to motivate the labor of handpainting. When trying to decide on a photo to handpaint, ask yourself the following questions: Does this photograph move me? Is the subject or place special? Can I take this image and say more with it? Do I want to say more? Is it powerful? Can I make it more dramatic with the use of color? Can I translate my feelings about this particular image to the viewer? If you answered these questions affirmatively, you're ready to proceed with that photograph.

As a beginner, choose images with simple compositions. For example, choose a portrait of one person filling a large percentage of the picture frame, as on the facing page. An uncluttered composition can help you achieve strong visual interest. People are a challenging subject to master, and the more people in the photograph, the more difficult the task. However, once you learn how to work with your paints, mix flesh tones, and work with facial details, painting two people, a family, or even a large group portrait will be manageable.

JOELLE IN A BATHING SUIT

When choosing an image for handcoloring, keep it simple. This uncomplicated, uncluttered shot provided the perfect opportunity to focus on color in one concentrated area—the swimsuit.

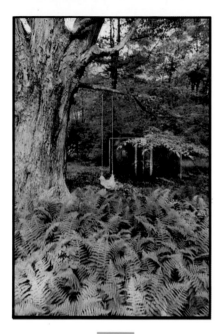

SWING

The sharpness of the foliage makes this image an overwhelming one for a beginner to tackle.

You could also opt to handpaint a *landscape,* which is any view of the countryside, town, sky, or even the sea. Understanding the point of interest and getting in tune with its rhythm, and with the balance of nature, are critical to creating a meaningful and original picture. A simple landscape encompasses large areas of subject matter; the goal of handpainting a landscape is to enhance an already great vista. Use color to say something that the photograph doesn't illustrate on its own. Simplicity is key. Avoid fine details, which can be difficult for the novice to paint. A simple cityscape, for example, would focus on a specific subject within the city, such as buildings, taxi cabs, pedestrians, or street vendors.

Still lifes, another option for the beginner, should also be composed of large shapes and contours. Bottles, glasses, and fruit work well. Keep the subject matter large enough to avoid fine details, such as small flowers or foliage. In general, always choose a simple photograph that's somehow meaningful. Mastering the art of handpainting is a long and wonderful journey; a simple photograph allows you plenty of room in which to express both emotional involvement and artistic skill. Early successes will ensure long-term commitment.

SPRING

The limited palette underscores the burst of lavender that heralds spring. To create this photopainting, I followed the strength of the various gray tones in the photograph.

SAN FRANCISCO

The simple composition of this scene allowed for a fun use of color.

PHOTOGRAPHING FOR HANDPAINTING

*C*apturing a moment in time is often the motivation behind taking a picture. We want to remember; we want memories. To create good photographs for handpainting you don't need to travel to exotic places. Interesting—even profound—images exist in your own surroundings. Look around and break down the visual details that define your world. What do you see on your walk to the train station? Do you have a favorite place to relax? Is there someone special in your life? What color are their eyes? How do they smile? Does their nose crinkle when they laugh? Where does the sun set in relation to your front door? What time does it set? Focus on what touches your soul; feel it and capture it on film.

I highly recommend taking photographs during the early morning or late afternoon, when the effects of the sun are more dramatic. These times are often referred to as the "magic hours" because the sun's low angle to the earth results in more diffused light, characterized by a beatific glow that illuminates shadows and creates interesting patterns. Arrange your shooting schedule to capture the appeal that natural light offers.

Other good opportunities for interesting photography occur during snow or rain storms, and on foggy, cloudy, or overcast days. Each condition will infuse the familiar world with new meaning. After a rain storm, for example, the freshly washed earth takes on a shimmering glow. People's skin tones also reproduce in a softer and more flattering manner in the naturally diffused light of a cloudy day. Landscapes seem more surreal and poetic at dusk or dawn when the sun caresses the earth.

Early-morning or late-afternoon light creates ethereal qualities, enhancing the subtle details of shadow and light. Working during these times often requires using a tripod and careful metering, but you can avoid the tripod by pushing the film (rating it faster than it actually is). Note, however, that this will create more contrast and more graininess in your final photograph. Sometimes, you may opt for a very grainy final working print; this quality works well for handcoloring, often highlighting a particular element of the picture. For images intended for handpainting, though, I recommend low-contrast photos, with less grain, which provide an excellent backdrop for the paints.

When taking photographs, always choose a camera with which you're comfortable. It should be an extension of your eyes. Keep your equipment simple so that you're able to truly *see* your surroundings. I use 35mm equipment, because I like its compactness. Plus, the 35mm negative translates easily to a 16×20-inch, and even a 20×24-inch, print while still maintaining beautiful sharpness and a fine grain quality.

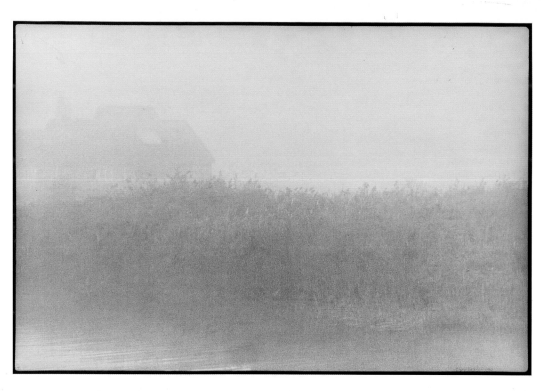

When photographing a subject, I recommend bracketing your exposures. This means taking one shot a stop above, and another one a stop under, the metered reading that your camera records. If you're confused as to what to take a meter reading from, purchase a *gray card* (available at most camera stores and through mail order catalogues—see Resources on page 143) and meter off that. This is a small board that typically has 18 percent reflectance and is used as a standard artificial medium tone for luminance readings.

Keep in mind that since you'll be handpainting, the gray tonal values of your photograph should be skewed toward the lighter end of the black-to-white spectrum. Black tones will be dense areas that are hard to cover with the transparent oil paints that we'll be using. This is why you should bracket; you'll get a variety of exposures that will allow you to select the negative that's most suitable for coloring.

INTERIOR, EARLY MORNING

To understand the importance of bracketing your exposures, take a look at this interior photopainting and its corresponding black-and-white images. I wanted to capture the effects of the rising sun dancing across the wall in this house in Camden, Maine. To get the most successful print for coloring, I took three different exposures (a light one, a medium-toned one, and a dark one) and used the best one—in this case, the dark one. Had I only taken the lighter exposure, for example, the entire atmosphere of the resulting painting would have been totally different.

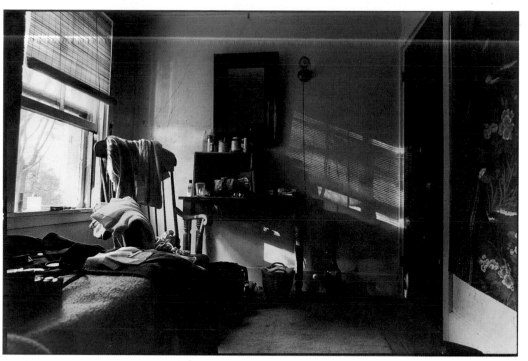

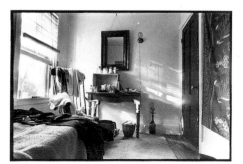

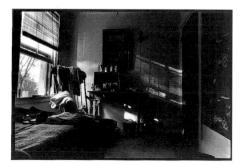

CHOOSING THE RIGHT FILM

*P*hotography is basically writing with light. Understanding illumination, therefore, is essential for selecting the appropriate film. I typically use ambient (natural) light, photographing my subjects (whether they're people or landscapes) during the magic hours and capturing the delicacies of the early morning, the late afternoon, or the enchanting light that immediately follows a storm. These low-light situations determine the parameters governing my primary choice of film speed, and the film speed, in turn, dictates the grain quality. So, choosing the appropriate film requires two basic considerations: film speed and grain size.

FILM SPEED

Black-and-white film is identified by manufacturer and corresponding film speed, such as Ilford FP4 Plus (ISO) 125. Film speed (indicated by the ISO rating) is used in conjunction with an exposure meter to determine the camera settings that will best produce a satisfactory image with that film. Film speed refers to the specific time required for light to reach the negative and make a latent image. Film requiring only a little light to record an image is called *fast* film, whereas film requiring more light is *slower* film. A film's speed, or ISO number, is shown clearly on the film packaging, and these ratings are constant worldwide.

A vast choice of black-and-white film speeds is available, typically ranging from ISO 10 (very slow) to ISO 3200 (very fast). For handpainting purposes and for 35mm or medium-format cameras, I recommend using ISO 125, a medium-speed film, or ISO 400, a high-speed film, which are versatile films with fine grains that enlarge well. For medium-format cameras, the ISO may vary depending on the manufacturer. Note that exceptionally slow films usually require the use of a tripod, and low-light situations require a tripod and a flash. If you don't own, or want to use, a tripod, select a faster film.

When getting started, purchase different brands of film at your chosen speed. Read the information on the film packaging and any other literature available from the manufacturer. Different brand films yield different results; with time, you'll discover the individual nuances of each brand and will decide on a favorite. Keep things simple by identifying your film preference early on and staying with that film.

THE GRAIN OF THE PRINT

The grain is the visible dots that make up a photographic print. Those dots can be fine and barely visible, or dark and coarse. The grain has a conspicuous effect on the overall

quality of the photograph, and so it is important to consider the desired result when selecting a film. As a general rule, grain size is a function of the size of the silver halide crystals in the emulsion on the film. There is a direct relationship between the grain of the film and the graininess of the final print. The larger the grain on the film, and the more you enlarge a negative, the larger the grain on the print. Conversely, the finer the grain in the film, the finer the grain on the print. As you enlarge an image, the grain of a fast-speed film typically becomes more evident than that of a slow-speed film.

Understanding the nature of your subjects and knowing your intended final print size are also important factors in selecting a film. Previsualization is key. Previsualization refers to the ability to look at a scene or location and imagine how photography and handpainting would transform it. For instance, I might envision a marsh that I want to photograph through a foggy mist. Therefore, I know that I must wait for a fog and that the ambient light will be low. So, I must select a film that will allow me to shoot under these circumstances.

DANICA AND LINDSAY

This image translated well into a 20 × 24-inch enlargement. The grain still remained relatively fine and didn't affect the overall feel of the photograph.

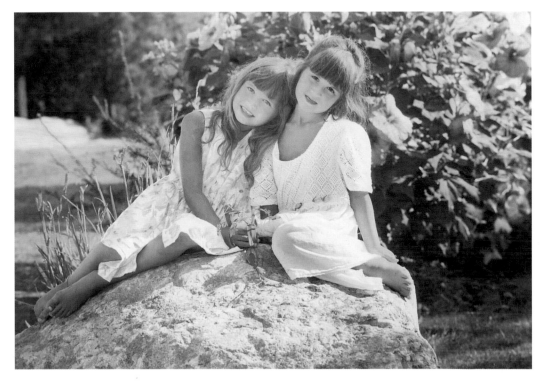

DRESS-UP: SELF-PORTRAIT #5, WITH NICOLE

These three photographs provide a good example of film grain in an image. I photographed this image on Ilford HP5 Plus 400 film, using a tripod and a self-timer. The top image below is the original 5 × 7-inch print; the lower image, which is a vertically cropped, 11 × 14-inch enlargement, is visibly grainier; and the handpainted version at right is the final image. It is also 11 × 14 inches, but I purposely printed it lighter to de-emphasize the grain, thereby achieving a more flattering skin tone.

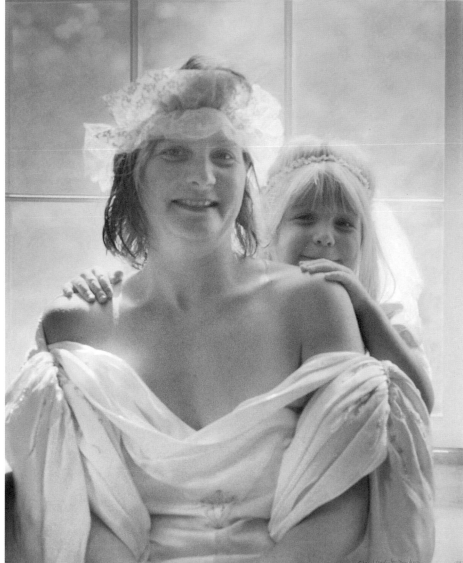

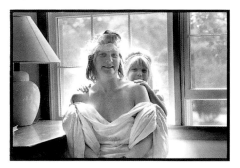

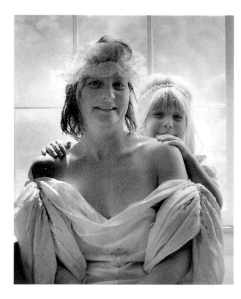

For portrait photography, I prefer using a medium-speed film. Due to the extra-fine grain, images enlarged up to 20 × 24 inches remain sharp and exhibit excellent tonal quality. Medium-speed film does have limitations in low-light environments, however; its sensitivity often requires shallow depth of field and a slow shutter speed, which often necessitates the use of a tripod. (In general, the shutter speed should be 1/60 sec., or greater than 1 divided by the focal length of the lens. For example, if I'm shooting with a 105mm lens, anything slower than a shutter speed of 1/125 sec. may result in an out-of-focus image.)

A tripod is obviously cumbersome when photographing a young child or an action shot, and this is often my predicament. Also, shooting group portraits and landscapes usually requires large aperture readings of $f/5.6$ and greater. This is often difficult to achieve using a medium-speed film in low-light situations without a tripod. Knowing these limitations and understanding the quality of the light enables me to select the appropriate film. In this situation, I have three choices. I can 1) push the film (set my camera to a faster ISO rating); 2) work with a faster film, say ISO 400, and push it if I have to; or 3) change the time of my photo shoot.

Usually, I use a high-speed film, such as ISO 400, when photographing in low-light situations, such as fog or dusk. In the late fall and early spring, recognizing the weaker light, I use ISO 400 for portraits, as well. Offering fine grain and sharp quality, faster film provides greater control over delicate light, allowing me to hand-hold my camera and select the aperture of my choice.

Grain isn't a major factor when you're working with 8 × 10-inch photographs. However, as you work with larger formats, the issue of grain size will present itself. Some people like grain and others don't. Look at photographs in magazines and books to determine your preference. For handpainting purposes, both fine and heavy grains can yield beautiful results.

To help you discover the many different qualities of the various films available, I suggest experimenting with the following four films: Ilford HP5 Plus (ISO) 400, Ilford FP4 Plus (ISO) 125, Kodak Plus-X Pan (ISO) 125, and Kodak Tri-X Pan (ISO) 400. Bring a few rolls of each on your photographic excursions. Before loading your camera with film, analyze the lighting. Take a test meter reading by setting your camera on the film's ISO rating, for example 125 for ISO 125 film. Then, meter off your subject, and see if you can work under those conditions. Ask yourself the following questions: Does the light permit me to hand-hold my camera? Does using a tripod present a problem? Will the aperture/shutter speed settings blur my subject?

Black-and-white films offer some latitude in ISO settings; you can rate a film above or below its ISO rating, and this flexibility enables you to accommodate various light situations and also fine-tune your knowledge of whichever film you're using. For

example, on a very bright day, I'll rate my ISO 125 film at ISO 60; cutting the ISO basically in half modifies the film processing time, and this, in turn, will have an effect on the grain size of the final image. Note that different films behave in different ways when you alter the processing speed, so it's important to learn these details about your film.

INFRARED FILM

Infrared film is a technical film that you can also use to create photographs for handpainting. However, its unique requirements necessitate its separate consideration and description. Infrared film is sensitive to nonvisible infrared wavelengths (near-red wavelengths longer than the extreme visible red), in addition to the visible light rays that black-and-white film usually records. Infrared film has many applications. Criminologists and scientists use the film to detect bloodstains, fingerprints, and forgeries. Aerial and landscape photographers use it to reduce atmospheric haze in their images.

Infrared, unlike the basic black-and-white film discussed in the preceding section, has idiosyncratic characteristics that set it apart from other films. It is extremely sensitive to light and must be loaded and unloaded in complete darkness. The film is not rated by the ISO (International Standards Organization), and therefore, the true film speed is unpredictable. Manufacturers include a suggested setting with the film, and it is recommended that you bracket every shot, exposing frames at least one stop above and one stop below your metered reading.

For the handpainter, it is advisable to use a red filter (either number 25 or 29) or an orange one (number 15). This enables the infrared film to record the near-red wavelengths, producing surreal and mysterious effects that are perfect for handpainting. Additionally, infrared has special focusing requirements and you should consult your camera manual for those.

Konica and Kodak manufacture infrared film, which can be purchased at photography stores and through specialty mail order companies. Ilford has recently introduced a "far red sensitive film," SFX 200, to the marketplace, which can produce near infrared results. It has an ISO rating of 200, and you can load it into your camera in subdued light. However, the use of filters—yellow, orange, or red (especially B+W 092 and Hoya R72)—is required to achieve the look of infrared and bracketing is still recommended. No focusing adjustments are necessary, though.

Typical characteristics of infrared black-and-white photographs include overly darkened skies, luminously glowing foliage, and feathery, bright white clouds. These qualities synthesize excellently with the medium of handpainted photography, as the incandescent near-white images allow for readily visible color application and result in surreal or otherworldly photopaintings. Experimentation and luck are always factors when using infrared film; this unpredictable nature is what attracts many to it.

Infrared Self-Portrait #1

Both the trees in the background and the flowers in the foreground of this image are unusually lustrous (almost as white as the paper itself) due to the use of infrared film. These light tones of the gray scale create an ideal canvas on which to handpaint. The luminous, near-white areas allow for highly visible color that often results in a surreal photopainting.

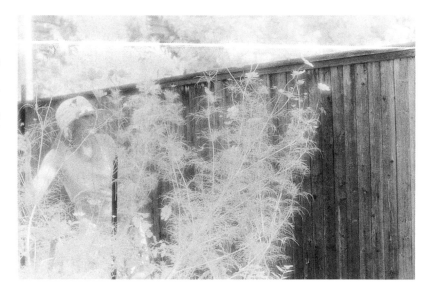

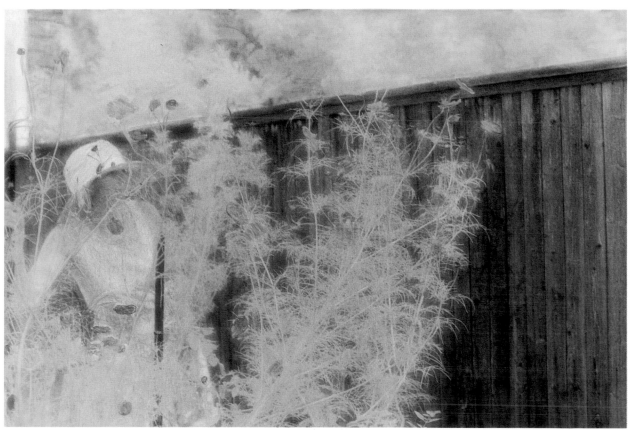

CHOOSING THE RIGHT PAPER

*T*here are many brands of photographic enlarging papers on the market, and each will affect the process and outcome of your handpainting. I recommend visiting a photography supply store and handling sample swatches, as well as trying a variety of papers.

RESIN COATED OR FIBER BASED

Photographic papers are typically either resin coated (RC) or fiber based (FB). Resin-coated paper has a water-resistant and plastic-coated, resin-coated, or polyethylene-coated base. This coating shields the paper from liquids during processing. Its efficient developing and fixing times, and its ability to dry flat, make it a popular choice among photo-enthusiasts. Fiber-based papers are made with high-quality, conventional paper materials that absorb water and chemical solutions. The paper itself isn't coated, so the processing time is therefore considerably longer. A professional dryer is required for ensuring flat prints, further adding to the developing cost. However, fiber-based paper is the widely accepted paper choice for archival and exhibition prints.

Fiber-based paper isn't always available at the local photo lab. Its time-consuming and finicky nature usually requires the handling capabilities of a more professional photography lab. Despite this, I suggest experimenting with the following fiber-based papers: Ilford's Multigrade IV FB and Ifobrom Galerie, Kodak's Ektalure and PolyMax Fine Art, and Luminos Charcoal R and Tapestry X. (See the chart on page 29 for more specific paper information.) You can inquire at your local one-hour photo shop about fiber-based printing services, or look in photography trade magazines, such as *Photo District News* and *Shutterbug*. If you do your own developing and are more comfortable working with resin-coated paper, I recommend the following brands, which accept some paint layering: Ilford's Multigrade IV, AGFA Portriga Speed, Kodak P-Max Art, and Luminos' RCR-ART.

COMMON PAPER CHARACTERISTICS

Black-and-white photographic paper has several characteristics: surface sheen, texture, contrast, base tone, and image tone. *Surface sheen* refers to the paper's finish. *Texture* describes the surface feel of the paper. *Contrast* pertains to the relative darkness or lightness of different parts of the photographed image. *Base tone* refers to the color cast of the shadows in a photographed image. *Image tone* defines the color of the paper itself as measured in the highlights of the photographic image.

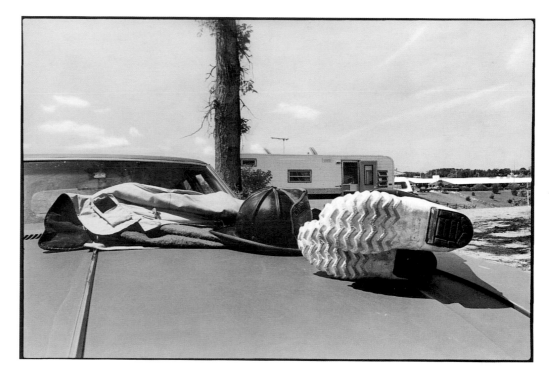

Surface sheens are commonly classified as glossy, luster (pearl) or semiluster, matte (flat or dull), and semimatte. I recommend fiber-based matte paper because it absorbs oils beautifully and offers ease of application for building up layers. Aside from absorbing the paints readily, matte papers also work best for handcoloring purposes because they tend to subdue the image, creating an overall soft effect that is often key for handpainting.

In addition to surface sheen, texture is another factor to consider. Paper is available in textures such as smooth, semitooth, or deeply textured. Tactile preference for paper surfaces is a very personal thing. A smooth surface produces the finest reproduction details and works well when layering color washes or creating mixed media renderings with both colored pencils and oil paints. A rough surface, on the other hand, bonds well with the paint, which is useful when retouching and handpainting. However, the rough tooth (texture) of the paper can be a hindrance to the smooth application of some handpainting materials. Generally speaking, a rough surface absorbs paint more readily but reveals pencil work more. My paper stock of choice is one with a smooth matte surface, such as Ilford Multigrade IV FB.

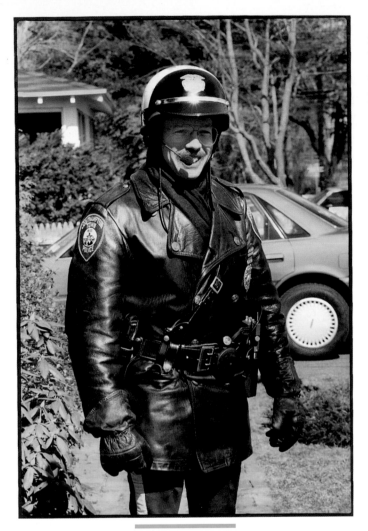

OFFICER WALTER BRITTON

Printed on Ilford Multigrade IV FB matte paper, this high-contrast image conveys the strong feel often associated with law enforcement officers. Multigrade IV FB paper is used with a high-contrast filter so that the contrast of the photographic print can be easily controlled.

Contrast affects the ratio of lights to dark in an image, thus dominating the overall look of a printed black-and-white photograph. Choice of film, exposure, and processing affects the contrast of the negative, and paper selection directly affects the printed result. Black-and-white papers are manufactured in specific contrast grades, or in variable contrast sheets. Graded papers range in contrast typically from one through five, with one being low contrast, five being high contrast, and two to three being normal contrast. Low-contrast papers result in prints that display variations of gray with no true black or white areas, while high-contrast papers produce prints with black and white areas and no grays. Variable-contrast, or multigrade, papers control the intensity of contrast with separately purchased filters used in the printing process. When used without filters, this paper is of normal contrast (grade two). Generally, I prefer a low-contrast print in which the white or light gray tones predominate, and the black is softened to a light charcoal gray, because a low-contrast print attains an overall soft effect.

There are certain instances, however, in which a high-contrast print works with the intended visual message. This type of print produces richer black tones, dictating stronger color application. Notice that the high-contrast prints, rich in black, are all painted with strong pigment. So, just like paper grade, printing a photograph darker, or lighter, affects the final handpainted image. As a general rule, to achieve rich color saturation, as in the image at left, print your picture darker, with added contrast. To achieve a soft effect, as in "Japanese Mist" opposite, print lighter, with low contrast.

The tone of black-and-white photographic paper is defined by two characteristics: image tone and base tone. Image tone describes the color of the silver image—the dispersion of color tint in the shadows of an image.

Base tone refers to the color of the paper tint as viewed in the highlights of an image. Black-and-white enlarging paper also has its own color, which is usually referred to as warm (having a brown cast) or cool (having a blue cast). Cool-toned paper projects a blue cast in the shadow area of the image, and warm-toned paper has a brown tint. There is also neutral-toned paper, which holds a rich black.

Image tone and base tone will affect handpainting. When working with portraiture it is easier to use warm- or neutral-toned paper to achieve a natural flesh color. The blue shadow tints of cool paper require skill to neutralize. On the other hand, cool-toned papers may be an excellent choice for landscapes, seascapes, or cityscapes, in which the blue cast echoes the natural color motif found in water and some buildings. Experiment with both types.

JAPANESE MIST

By choosing a low-contrast paper for this image, I was able to capture the quiet, subtle feel of this misty scene. Notice that there are no areas of strong black tones in the photograph, only white, light gray, and charcoal gray.

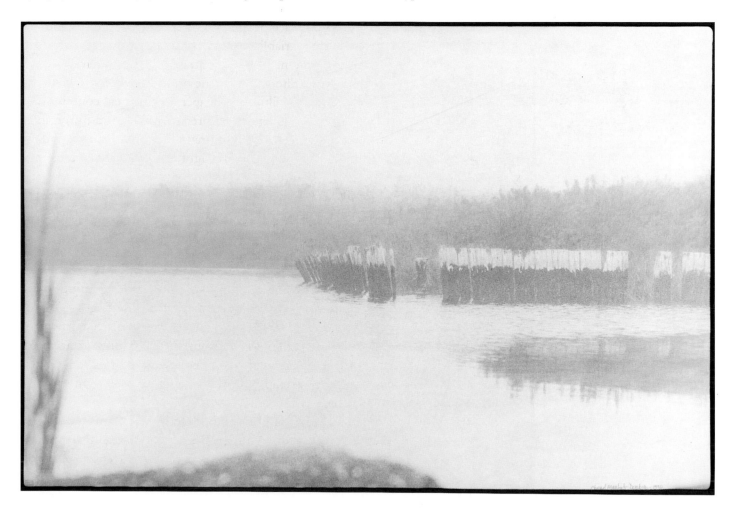

Paper comes in several different standard precut sizes: 8 × 10 inches, 11 × 14 inches, 16 × 20 inches, and 20 × 24 inches. The smaller 8 × 10-inch or 11 × 14-inch enlargements are convenient sizes on which to work. They're large enough to allow you to learn all the mechanics of the handpainting technique, yet small enough so that you can maintain control. Economically, they also make sense; small prints are significantly less expensive to produce than larger ones, so mistakes are less costly. Once you learn the skill of handpainting, you'll probably desire a larger painting surface on which to express yourself more freely. At first, larger paper may appear intimidating, however, I find that larger sizes dramatically enhance the beauty of handpainted photos; it is worth aspiring toward the use of larger sizes. Still, struggling to subtly sweep washes of color across a large surface can be a challenge, and mistakes are more costly. In general, 16 × 20 inches is my standard working size.

Hurricane Bob

In the print at top left, the grass in the foreground of this image is too luminous for a realistic storm interpretation. Printed like this, the grass takes on the qualities of an infrared photo. Printed darker, however, as in the top right version, the image takes on an ominous appearance appropriate for a major storm.

In the handpainted image below, notice how, due to the darker printing of the photo, the somber gray sky needs very little paint to enhance the feel of the threatening winds and approaching storm.

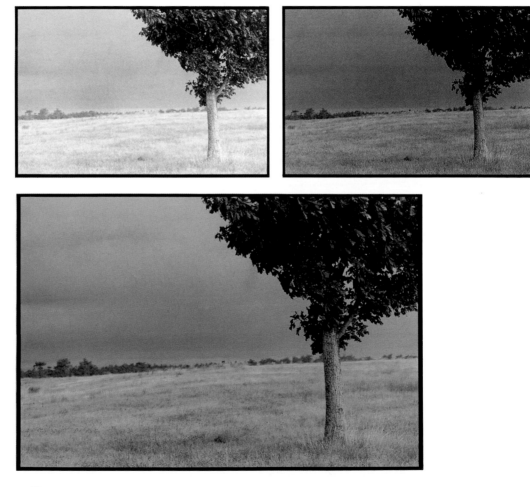

PHOTOGRAPHIC PAPERS

Below is a chart of fiber-based and resin-based papers. It lists all the different aspects of each paper type for easy reference. I suggest experimenting with a few different papers to find the one that's most suitable to your handpainting needs and tastes.

FIBER-BASED PAPERS

Paper	Texture	Base Tone	Image Tone	Contrast	Surface
ILFORD					
Multigrade IV FB	smooth	white	neutral	variable	matte
Ilfobrom Galerie FB	smooth	white	neutral	1 to 4	matte
Multigrade FB—warm tone	smooth	cream	warm	variable	semimatte
KODAK					
PolyMax Fine Art	rough	white	neutral	variable	semimatte
LUMINOS					
Charcoal R	textured	warm	warm	1 to 5	semimatte
Tapestry X	rough textured	warm	warm	1 to 5	semimatte
Photo Linen	linen	warm	neutral	1 to 5	linen
AGFA					
Multicontrast Classic	textured	white	neutral	variable	semimatte (118)
FORTE					
Neutral Tone Polygrade FB	smooth	white	neutral	variable	semimatte
Warm Tone Polygrade FB	smooth	white	warm	variable	semimatte

RESIN-COATED PAPERS

Paper	Texture	Base Tone	Image Tone	Contrast	Surface
ILFORD					
Multigrade III RC Rapid	smooth	white	neutral	variable	matte
KODAK					
P-Max Art RC	tweed	white	neutral	2, 3	matte
LUMINOS					
RCR-ART	tooth	white	neutral	2, 3	matte
AGFA					
Multi-Contrast Premium	tooth	warm	warm	variable	matte (312)

TONING YOUR PRINTS

*T*oning is a chemical process (a chemical bath) in which you purposely alter the photographic base tone and image tone of a print with a toner. Selenium, gold, blue, and sepia are the toners I most commonly use. Blue toner will change the hue of a picture to blue, a gold one will change the hue to gold, selenium to magenta, and sepia to yellow-red. Additionally, you can use these toners to enhance the life of a photograph, shielding the silver image from environmental pollutants.

Sepia seems to be the most popular toner for handpainting. The dye warms the silver image to a pinkish or yellowish hue, although the color will vary depending on the paper used. Sepia toning is especially applicable to handpainting when the final photopainting warrants a palette rich in brown and yellow pigments. Consider the series of photographs opposite of the child in a corn field.

Sepia toning does have its limitations in handpainting, however. Its stylized look can often dominate an image. Used indiscriminately, a handpainted sepia print looks very obviously like a sepia print that's handpainted. Additionally, the sepia tone often overshadows the applied pigments and painterly attempts; the yellow or red tone interferes with a wide range of colors and limits your palette. Sepia is also so beautiful that it often doesn't really warrant further painting of the image.

Overall, toning can be a valuable preparatory step in the handpainting process. It's important, though, to previsualize your picture, mentally formulating the look you want to achieve. Then, used strategically, toning can enhance a handpainted photograph, whereas when misused, toning needlessly inhibits paint application.

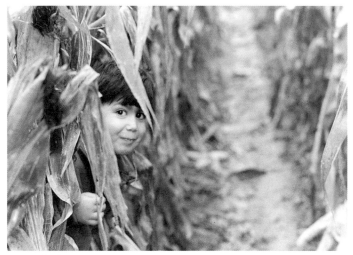

1. This is the untoned, unpainted image.

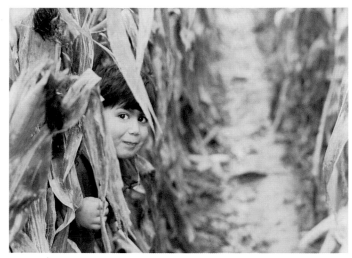

2. Here, the picture has been handpainted with no preliminary toner applied. Notice how the blue cast of the normal gelatin silver print creates cool, blue shadows in the flesh tones. The overall look is cold, which isn't quite appropriate for the subject matter.

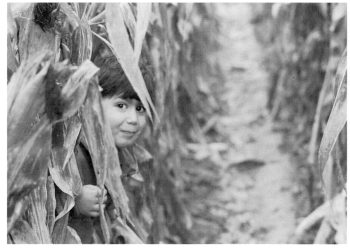

3. This version of the unpainted print has a sepia toner applied to it. The toner adds a warm hue to the image; you can almost feel the corn.

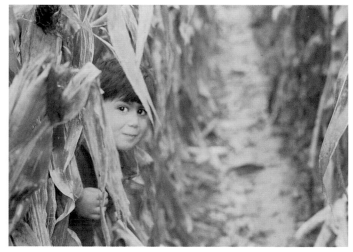

4. This final version, which shows handpainting over a sepia toner, exhibits a warmer, more flattering skin tone. Yellow works well on sepia tones, so I'd recommend trying sepia toner on images for which you intend to use a palette rich in this color. Note, too, how the warm cast of the sepia toner works well for this subject.

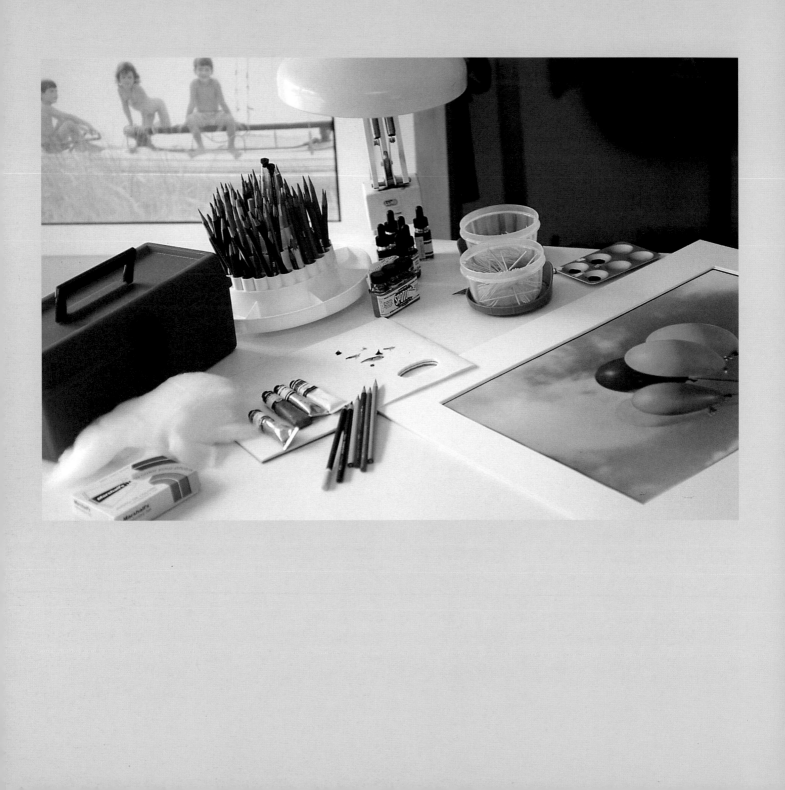

MATERIALS AND THE WORK STATION

*Whether I'm walking through an art store or working in my studio,
inhaling the smells of oil paints, turpentine, and linseed oil always invokes
a sense of nostalgia. Once again I'm 15 years old, sitting on a wobbly
wooden stool, painting in art class. Week after week, the intoxicating
aromas of that funky art school encouraged my dreams and ignited my
imagination, transporting me to Paris, Montana, and Jamaica,
inducing visions of effervescent twilights, open skies, and tropical sunsets.*

—**Cheryl Machat Dorskind**

This is a typical handpainter's workstation; it is complete with supplies and rife with possibilities. Having the proper materials is important; it frees you to explore every avenue and be as creative as you can.

*B*eyond the dream there's the practical application. Still, I treasure my jaunts to the art store, where I search for new materials and tools for my art. I lose myself in the sensory exploration of touching the bristles of the paint brushes, looking for new paint colors to add to my palette, browsing through art books, and investigating new mediums and applications. My quest is continuous and keeps my art alive and fluid.

Virtually any artist materials are acceptable for handpainting photographs. Oil paints, watercolors, colored pencils, enamels, acrylic paints, and markers all work well. The chosen medium and method of application greatly affect the look and intended message of the photopainting. I often struggle to achieve a purposely subtle effect, leaving viewers unsure of the visual medium and wondering whether or not the photo is truly handpainted. And while handpainting requires many artist and photographic materials, you only need a few items of equipment to set up a suitable work area: a space that you can claim as your own, a table or countertop, paper or foam board, a good light source, and adequate ventilation.

The materials recommended in the following section are only a starting point. As you learn the various aspects of the handpainting process and become more familiar with your own vision, you'll undoubtedly discover your own unique style and the materials that enable you to best express it.

Basic Supplies

*T*he following items, all of which I'll cover here in detail, are staples for the handpainter's tool box: oil paints, colored pencils, pastels, extender, primer, cleaning solution, spotting agent, frisket, cotton, paintbrushes, tortillons, skewers, and toothpicks, plus a straight edge, X-Acto knife with #11 blade, cutting board, pencil sharpener, and disposable gloves. You can find all of these things in art supply stores. White cotton gloves are useful for handling photographs, because they protect against fingerprints and oil residue, and vinyl gloves (the kind used by medical professionals) are great for shielding your hands from chemicals and paints. Also handy is a surgeon's mask, as an added precaution against fumes from sprays, wetting agents, and primer applications.

Spotting Kits, Pens, and Pencils

Spotting kits, for spotting out imperfections in a photographic print, are available in photography and art supply stores and are a necessity for producing beautiful handpainted photographs. There are many brands and types of spotting materials made specifically for black-and-white photography, including kits from Kodak, Marshall's, Spotone, and Marabu.

SpotPen is another tool available for spotting photographs and is available in sets of 10 premixed spotting brushes for neutral-based and warm-toned black-and-white photography paper. All-Stabilo and Gamma are all-surface pencils (meaning they write on all types of surfaces) for concealing small imperfections on photographs; they can also be used on glass, plastic, and metal and are good tools to have around. The gray and black pencils work well for simple photographic spotting jobs, which I'll explore in detail in chapter 4.

Oil Paints for Photographs

Many types of paints can be applied to photographs, but I prefer using Marshall's Photo Oil Colors. Unlike most oil paints, Marshall's are transparent in nature, like watercolors, and are manufactured specifically for painting on photographs. They provide greater control than colored dyes and allow the tones of black-and-white photographs to remain visible through their pigment. You can add Marshall's titanium white paint to any of their other oil colors to make them opaque, foregoing their inherent translucent quality.

Marshall's oils are available in five different kits: the Introductory Set, which includes five colors and primer; the Learn-to-Color Set, which includes nine colors, primer, extender, and cleaning solution; the Hobby Set of 15 colors, primer, extender, cleaning solution, and drying solution; the Advanced Oil Set of 20 colors, primer, extender, cleaning solution, and drying solution; and the Master Set of 46 colors, primer, extender, cleaning solution, drying solution, and varnish. Although the limited palette of the introductory set necessitates extensive paint mixing and blending to produce a variety of colors, color mixing is a skill you must eventually develop in order to create sophisticated handpainted images. So, this is actually a benefit of working with the small kit, and it is for this reason that I often supply Introductory Set kits to my new students. Conversely, the large selection of colors in the Master Set may prove overwhelming at first. Your eagerness to play with the multitude of colors may actually obscure tasteful color selection.

Marshall's Photo Oil Colors are also available in individual tubes, both small and large, at select art supply stores and through photographic and art supply mail order catalogues (see Resources). There are a total of 53 colors. I recommend purchasing a kit, familiarizing yourself with those colors, and then replenishing or enhancing the paints with some individually purchased tubes.

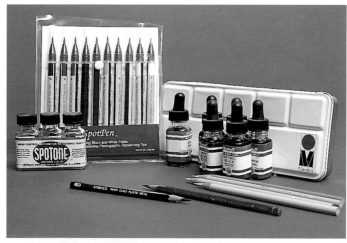

Photography spotting kits, pens, and pencils.

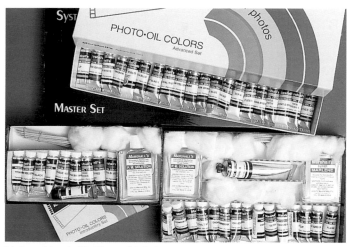

Various Marshall's Photo Oil Colors paint sets.

COLORED PENCILS

Quality colored pencils are an excellent medium to use when handpainting photographs. Reputable brands include Berol Prismacolor, Derwent, and Marshall's among others. Colored pencils are transparent in nature and are available in a multitude of colors. You can use them alone or in conjunction with Marshall's oil paints, and they're perfect for rendering areas of fine detail, such as eyes, lips, foliage, and clothing.

The visual impact of colored pencils is often heightened when they're layered, and they're particularly useful for building highlights and shadow details. You can also use them in large areas and can even handpaint an entire photograph with pencils only. You can purchase artist-quality colored pencils individually or in kits at art supply stores and through catalogues. Test different brands and purchase a few to see which ones perform best. One testing trick is to turn a sharpened pencil on its side and press down with the side of the pointed edge to see if you can spread or feather the color. Pencils that spread readily are most desirable because they can be easily applied to a photograph, and the soft lead enables good blending. Note that you'll also need a pencil sharpener to maintain fine points on your colored pencils.

Schwan-Stabilo manufacturers pastel pencils that look just like a colored pencil. They're available in a large assortment of colors, and I use them on occasion to emphasize a specific color plane, to soften the black areas in a photo, to render foliage, and when working on vintage photos. The coverage is chalky, like a pastel, but they blend with the oil paints and colored pencils to create layers and unusual nuances of color.

Colored pencils from various manufacturers.

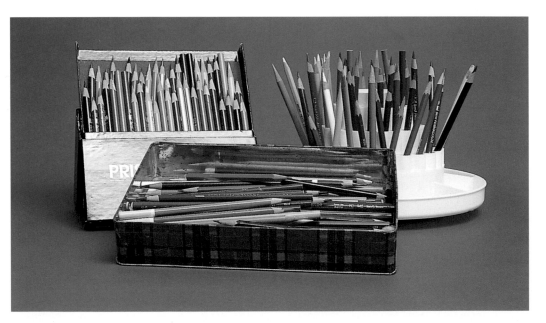

RACHEL

I "painted" Rachel's playsuit entirely with colored pencils. To do this, you should first apply a preliminary wash of extender or paint color to the design and then add layers of colored pencil over this to create specific patterns, textures, or colors.

1993 Cheryl Meeker Heykoop H

EXTENDER, CLEANING SOLUTION, AND PRIMER

Extender is a gel used to help move oil paints or colored pencils across a photograph. Extender also thins the concentration of the oil color. Extender works like turpentine but its gel form makes it easier to control; plus, there's no odor as there is with traditional turpentine (although you will probably be able to find "odorless" turpentine or paint thinner). Additionally, you can use extender to remove unwanted paint from a photograph. Marshall's sells extender in individual tubes. It's included in their larger paint kits but not in the Introductory Set, so I'd suggest buying a tube of extender if you're using the smaller Marshall's paint kit.

Cleaning solutions are a necessary item for removing unwanted paint from a photograph. You can also use extender to remove paint from small areas, and this is the preferred cleaning agent because it is odorless. For cleaning large areas, though, or for removing paint from an entire photograph, you'll need turpentine, Marshall's Marlene, or Marshall's P. M. Solution. The advantage to Marshall's Marlene over the P. M. Solution or turpentine is that it is easier to control. However, all three of these cleaning solutions contain hazardous ingredients and should be used with caution and in well-ventilated working areas while wearing gloves.

Tubes and bottles of Marshall's Extender, Marshall's Marlene cleaning agent, Grumbacher turpentine, Marshall's P. M. Solution, and skewer applicators.

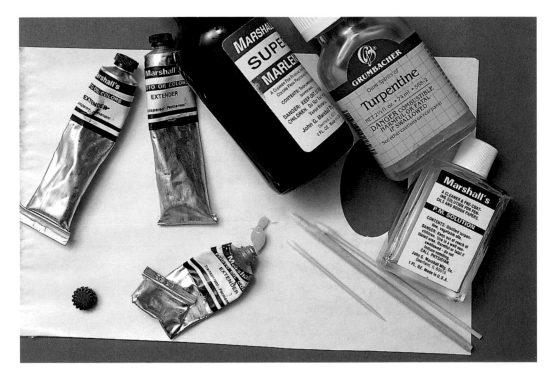

If you don't like the manner in which you're painting a photograph, you can, with caution, wipe the entire print clean using a cleaning agent. Note that Marshall's Marlene will strip the primer off the print (see next paragraph) so you'll have to apply another coat of primer before continuing to paint. Personally, I try to use extender for all my cleaning. If I want to start over again, I'll opt to use a second print, rather than expose myself to the fumes of Marshall's Marlene.

Primers, which are another necessity, are specialized liquids or sprays that prepare the photographic paper surface to receive paints, pencils, and pastels. Often, priming is a necessary preparatory step. To give glossy papers the necessary tooth or texture for oil paint or pencil absorption, you'll have to spray them with matte spray lacquer primer. Without this, oils would rub right off the surface of the photograph, and colored pencils wouldn't adhere and would leave indentations on the photo. There are many professional primers on the market, including lacquer spray primers by both McDonald and Grumbacher. Note that you should only use these products in well-ventilated areas or, preferably, outdoors.

Matte-surface and matte-sprayed papers often require a coating of liquid primer to control the flow of oils and colored pencils. I use the Marshall's P. M. Solution mentioned above, which is a liquid mixture of turpentine and vegetable oil, specifically for this purpose. You can substitute plain turpentine for this, however it evaporates rapidly and therefore requires that you work swiftly. The P. M. Solution offers more control since the vegetable oil creates a thick liquid that doesn't completely evaporate. To apply, you put down a coat of P. M. Solution on the paper surface using a piece of cotton and then rub off the excess with a tissue. (See chapter 3 for a detailed explanation of this procedure.) P. M. Solution allows you to mix the mediums of paints and pencils, blending and building color for a painterly effect.

Brushes, Skewers, and Tortillons

You'll need fine-pointed brushes for doing spotting work and occasionally for actual painting. I recommend purchasing three spotting brushes in various sizes: #000, #0000, and #00000. These are brushes made specifically for spotting and for executing fine detail work. Their bristles are a blend of natural hairs (often sable) and are quite thin; they're made to hold a fine point, which is essential for spotting. Also consider purchasing a longer-bristled, but still delicate, brush for painting small details such as eyes or lips.

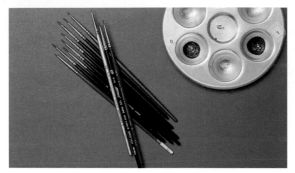

Brushes for spotting and painting fine details.

MERIENNE AND JOSH

When working with small (8 × 10-inch) images, keep the clothing simple. This photograph, which was 20 × 24 inches, involved painting that required the use of a very fine brush, especially for rendering Merienne's dress.

MERIENNE AND JOSH (DETAIL)

Without a fine paintbrush, I wouldn't have been able to successfully capture the delicate pattern of Merienne's dress and hair bow, and the overall tender feel of the photopainting would have been lost.

You'll also need toothpicks and skewers of different lengths (see page 69 for a picture of skewers). I find that the 4$\frac{1}{2}$-inch-long skewers work best. You can purchase skewers in all different sizes in restaurant supply and home appliance stores (anywhere they sell barbecue skewers), or in art supply stores and even at drugstores. Look for skewers that are pointy on at least one end, like a toothpick. You'll eventually be wrapping the skewers in cotton, as I'll show you in chapter 3, to make a special brush; purchase the very best, 100-percent cotton, which is available in rolls (don't use cotton balls or puffs). You can find this cotton in most drug stores in the first aid or surgical supply sections, and it usually comes in 2oz., 4oz., 6oz., 8oz., and 1lb. boxes.

Tortillons are implements of tightly woven cotton that can be used for burnishing layers of colored pencils. They are available in art supply stores and mail-order catalogues (see Resources).

FRISKETS FOR MASKING THE BORDER

Frisket is a masking fluid that you can apply to a surface to repel paint or otherwise protect the covered area from further color applications. You would use it to preserve the original color of the paper, or the underlying color of that area. Foto Frisket Film, manufactured by Badger, is a low-tack (not too sticky), soft-peeling masking film that comes in rolls or flat sheets of a variety of widths and is used to mask a photograph's borders for a clean final presentation. You can buy frisket film at art supply stores.

I'll explain how to work with frisket thoroughly in chapter 3, but you'll need a cutting surface and knife. I find that an X-Acto knife with a #11 blade is a good choice. A resealable cutting surface is also a worthwhile investment; this is a specially manufactured surface that self-heals after you make each cut, providing a consistently unblemished cutting surface. Though expensive, it will last for years. The boards come in clear and dark green in varying sizes. If you don't want to purchase this, you can use a piece of cardboard or scrap mat board as a cutting surface.

SETTING UP A WORK STATION

*H*andpainting requires a space that you can claim as your own—a place where you won't be interrupted, a place that provides quiet and where you can use paints and chemicals carefully but freely. Ventilation is important, and any work area must have windows. Cross ventilation is ideal. Additionally, natural outdoor light is the best and provides added inspiration (hopefully) for your work. Try to create a space in which it is possible to get in a few hours of uninterrupted creative work at a time. Ideally, you'll want an area where you can safely leave works in progress untouched. Don't leave any chemicals around children. Like medicines and other toxins, store your handpainting chemicals and materials carefully and securely out of the reach of children.

The top of any surface can serve as your work table. A drawing board or table, a standard desk, or even a countertop will suffice. Choose as large a work surface as possible. I work at a large drawing table that's 54 inches long by 38 inches wide, and even it gets crowded when I work on large prints. It is also important to protect your work surface from unwanted paints and chemicals, which will undoubtedly rub off onto the table. Some paint colors are permanent. Newsprint provides an economical

This is a view of my studio, complete with a large window providing natural outdoor lighting, a large drawing table with a functional desk lamp, a desk chair, a lightbox for viewing slides, and another tabletop surface for other items. I keep a small stereo system in my work room, because I find that listening to music encourages my creativity, and a comfortable chair for contemplating my work or just taking a break. I also have a small bookcase for reference books that I find inspirational.

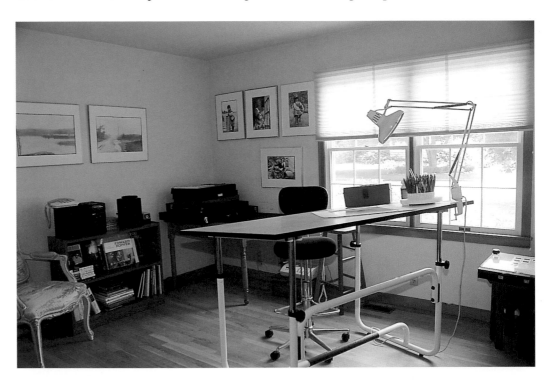

barrier and is available in pads of various sizes at most art supply stores. Simply cover your surface with it. I also recommend covering any working surfaces or tabletops that have nicks or grooves in them with foam core or mat board in pieces larger than your photos; otherwise these nicks might damage your work when you apply pressure to your photographs during the painting process.

Proper lighting is an important factor in the handpainting process. Bright ambient light is the preferred light source, and working in a naturally lit room is ideal. If possible, move your work table near a window. Also, invest in a "combination" desk lamp, one that utilizes both fluorescent and incandescent bulbs simultaneously; the two types of light, when used in conjunction, produce a good natural ambience. These lamps, manufactured by Dana, Luxo, Affordable Lighting, and others, are available at art supply stores (see Resources). I also find that music is a wonderful companion during the solitary and time-consuming process of handpainting. It provides a source of inspiration and relaxation, and after mastering the basic handpainting skills, music can free your mind, encouraging spontaneous and creative work.

Once you've defined your work space, you must prepare it for handpainting. To do this, clear it so that it is suitable for concentrated, creative energy. A neat, appealing area will encourage creativity, while a cluttered space will inhibit your ability to produce successful photopaintings. Arrange all your materials nearby for easy access, and continually remove any used cotton or other garbage from your work station. The paints can be very messy, and this will help you avoid rubbing unwanted color onto your photos. Just as a sushi chef wipes clear the surface of his countertop and cleans his knife after every order, so too must the handpainter diligently attend to his or her studio.

A dual or combination task lamp is a necessary item for any studio, especially those with minimal natural light. Lighting affects color selection and paint mixing and is, therefore, very important to the handpainter. It is imperative that you work with the clearest, most natural lighting possible to best produce the colors you see in nature.

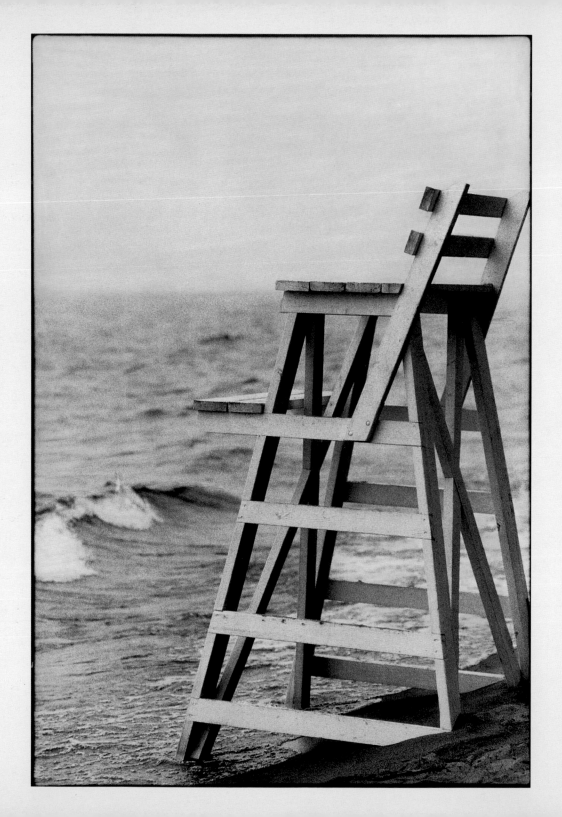

BASIC COLOR THEORY

*I understand how scarlet can differ from crimson because I know that
the smell of an orange is not the smell of a grapefruit. . . . Without color
or its equivalent, life to me would be dark, barren, a vast blackness. . . .*

—*Helen Keller*

You could spend a lifetime studying color. There's so much information on the subject, ranging from the highly technical, scientific, physiological, and psychological to the sublime. The process of handpainting photographs poses questions regarding the nature of color. How you see the world and how you intend to illustrate this vision is dictated by color. Handpainting takes photographically perceived forms one step further, giving them refined definition through the selective addition of color. That is the power behind this medium. The use of color and its narrative voice is a tool to enhance black-and-white photography, giving it new dimension and, perhaps, new meaning.

In 1987, I had the opportunity to spend an afternoon with the poet and photographer, Allen Ginsberg. The comments he made while reviewing my portfolio remain instrumental in focusing my objectives as a handpainter. He asked me: Why did you paint this sunset pink? Is this the color you saw? Is the color saying something? Defensively, I replied that I chose my colors because I liked them. But he insisted that liking isn't enough, adding, "You have to know *why* you're handpainting. Your photographs are beautiful in themselves so why put paint on them. What are you trying to say?"

These questions resound in my mind even today while I paint my photographs. Certainly, I could have painted my images in a more realistic fashion, or could have settled for black-and-white photographs, but I didn't. What am I trying to communicate? Color must be understood and respected in order to have any power. Handpainting can be a random display of exuberance, a replica of reality, or a precise expression. As Gustave Flaubert pointed out, "One must not always think that feeling is everything. Art is nothing without form."

LIFEGUARD CHAIR

The strong contrast of this photographic print provided an excellent canvas for vibrant color saturation.

The form under examination is color. The colors of the spectrum are wavelengths of light made up of electromagnetic energy. However, the light waves aren't the colors themselves; their color originates in the human eye through color absorption and reflection. An object or pigment appears to be a certain color depending on which light rays it reflects or absorbs. For example, a lemon appears yellow because it absorbs all but the yellow light waves, which are reflected back to the eye. To better understand, use, and mix color, let's consider a few basic principles of color theory.

The basic color wheel has 12 colors. The three primary colors—red, yellow, and blue—appear equidistant from one another. Between them fall the three secondary colors—orange, green, and violet—and the six tertiary colors—red-orange, yellow-orange, yellow-green, blue-green, blue-violet, and red-violet. The wheel is useful because it shows the relationships between the colors, which will help you when mixing and choosing pigments for your photopaintings.

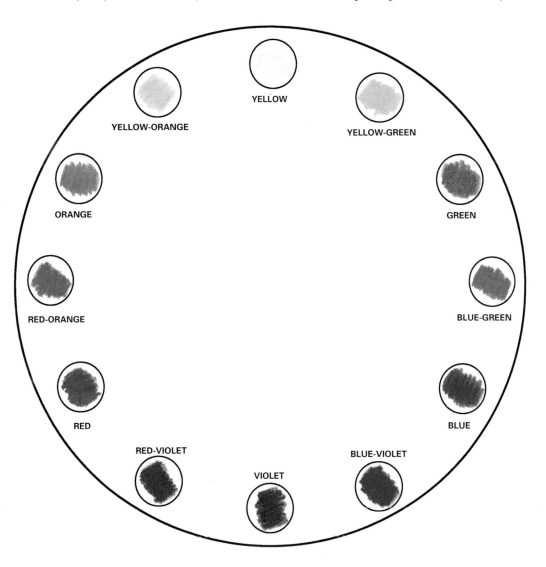

YELLOW

YELLOW-ORANGE

YELLOW-GREEN

ORANGE

GREEN

RED-ORANGE

BLUE-GREEN

RED

BLUE

RED-VIOLET

BLUE-VIOLET

VIOLET

THE COLOR WHEEL

*T*he color wheel is a universal visual artist's tool useful for depicting and explaining the logic, organization, and properties of color. It helps the painter understand color mixing and paint applications. Ultimately, a well-executed photopainting must incorporate the fundamental principles of color. Even if you have a good, innate sense of color, you'll inevitably reach a point at which your next color choice won't be readily apparent. A wrong color choice can throw off an entire picture. Informed color selection and mixing heightens your ability to create successful photopaintings. As Joe Singer writes in *How to Paint Portraits in Pastels* (Watson-Guptill, 1972), "Color is a mercurial creature that like a frisky horse must be kept under tight control. If you give color free rein, it'll run rampant and cause irreparable damage."

The color wheel will assist you in the struggle to communicate in an aesthetically pleasing and effective way; it displays the basic properties of, and relationships among, the colors, which you can then apply to the handpainting process. The color wheel comprises 12 colors, and its foundation is the three *primary* colors—red, yellow, and blue—so termed because they cannot be produced from any other colors.

The *secondary* colors are created by combining any two primaries—red and blue make violet, red and yellow make orange, and blue and yellow make green. Notice the placement of the secondary colors on the wheel: each secondary lies between the two primaries that yielded it. *Tertiary* colors are formed by mixing a primary color with a secondary. There are six tertiary colors: red-orange, red-violet, blue-violet, blue-green, yellow-green, and yellow-orange. Notice that, like secondary colors, the tertiaries also fall between the two colors that created them.

In addition, colors are also described in terms of temperature. They are either warm or cool. For example, warm colors are the yellows and oranges associated with sunlight, while cool colors are the blues and violets associated with shadows. Warm colors advance, appearing closer to the picture plane, while cool colors recede. Note, too, that every color can seem either warm or cool; there are cool reds and warm blues.

Making your own color wheel will enhance your knowledge of color, and I suggest doing this. To begin, start with a circle and think of it as the face of a clock. Using the color wheel opposite as a guide, place yellow at 12 o'clock, violet at 6 o'clock, blue at 4 o'clock, and orange at 10 o'clock. Then fill in the remaining colors. You can also buy color wheels at most art supply stores. Charts such as those manufactured by Grumbacher and Koh-I-Noor include color terms and information. Whether you make a wheel or purchase one, always keep your wheel at your work station. It will prove invaluable.

COMPLEMENTARY COLORS

*T*wo colors that fall directly opposite each other on the color wheel are known as complementary colors or complements. Complementary pairs consist of one primary and one secondary color—for example, red and green, yellow and violet, and blue and orange. When mixed together in the correct proportions, complementary colors produce a neutral or gray color.

Familiarizing yourself with complementary colors is useful for creating dramatic effects in your painting. Complements placed directly next to each other in a composition invoke a bold sense of color, each intensifying the other. Combining a color with its complement subdues the intensity of that color. For example, if you want to temper the strength of a red ball, mix the red paint with a touch of its complement (green). Complementary colors can be bold or subtle, but the properties of complements remain constant and maintain their function as a tool for the artist, regardless of their value (relative lightness or darkness).

BALLOONS

In this composition, I placed the complements red and green side by side to help focus the viewer's attention on the center of the image.

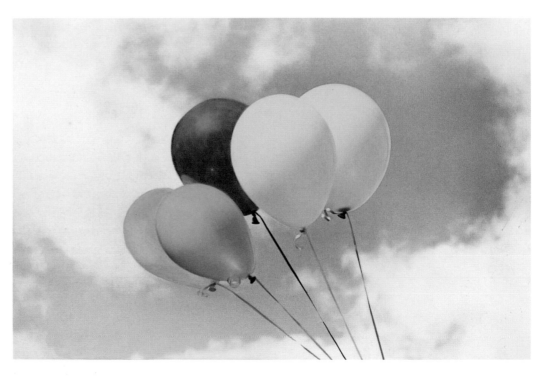

Barber Shop

Here, the vibrant green of the window molding is accentuated by its complement, the red in the barber shop pole. The reddish railing in the foreground further leads the eye into the picture.

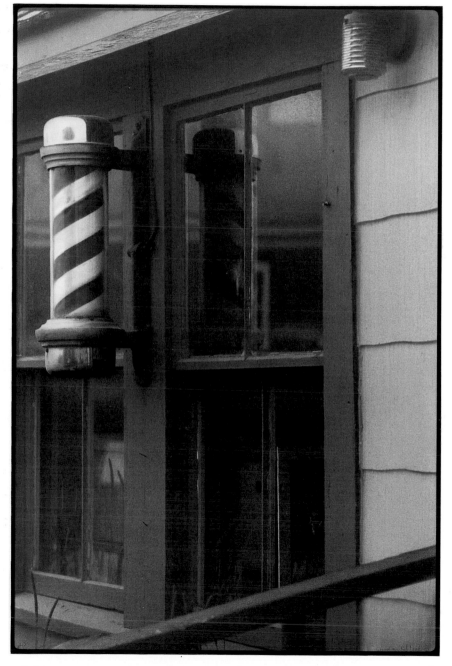

Color Harmony

\mathcal{T}he term *harmony* implies balance and order. Harmony in a composition is the result of a balanced relationship between all of the visual elements. Color harmony in a photopainting is achieved when there's a pleasing relationship between the three dimensions of color: hue, value, and intensity. While personal taste plays a large role in your vision of color harmony, a general understanding of these three standard aspects of color is important.

While reading this chapter, keep in mind the following points from Betty Edwards' book *Drawing on the Right Side of the Brain* (J. P. Tarcher, 1989). They should help you balance color and achieve harmony in your photopaintings.

1. Every hue has a complement.
2. For every hue of a given intensity there is the same hue at the opposite intensity.
3. For every hue of a given value, there is the same hue at the opposite value.

Hue

The word *hue* simply refers to the name of a color. Yellow, sap green, red-violet, orange, and aquamarine are all examples of hues. In *Interaction of Color* (Yale University Press, 1963), Josef Albers astutely described the many hues of similar colors this way:

> Usually we think of an apple as being red. This is not the same red as that of a cherry or a tomato. A lemon is yellow and an orange is like its name. Bricks vary from beige to yellow to orange, and from ochre to brown to deep violet. Foliage appears in innumerable shades of green.

The 12 colors identified on the color wheel are all hues. However, within these color categories fall other pigments; there are many pigments within each category. Consider the number of oil paint colors available. For example, red-orange is a hue, and vermilion is a pigment or paint color belonging to this red-orange category. To change a hue, you simply mix it with another color. For example, mixing blue with green creates a bluish-green hue.

Value

This term describes a color's approximate lightness or darkness in relation to white and black. When a color is closer to white we say that it is lighter in value. For example, yellow is lighter in value and closer to white, than violet, which is darker in value and closer to black.

Just as you can change a hue through color mixing, you can also alter the value of a hue, making it lighter or darker. Every hue has a value range of tints and shades. To lighten a hue, creating a *tint*, you mix it with white or a diluent of some sort. In handpainting, you thin paint colors with extender to dilute them and create tints. (You use extender rather than white pigment to maintain the transparency of the paint.) The effect is similar to that of watercolors diluted with water. To darken a hue, creating a *shade*, you mix it with undiluted black or a darker pigment within the same hue category. Note that the black and gray tones in your photograph will also help darken a hue.

The element of value is important in handpainting because with this knowledge you control the emphasis of your subject matter and composition. In addition, you design elements through contrasts in highlights and shadows, working with the values of the underlying photograph to simulate form.

BRITTANY, CHELSEA, AND JULIEN

Every hue has a perceived temperature, and you should use this information when choosing your colors. In this image, I balanced the warm hue of the apples with the cool blue hue of the overalls. This causes the apples to really stand out as a point of interest in the image. Notice how they advance toward the picture plane, while the cool blue of the denim recedes. The background of green (as the complement of red) provides that extra element to tie the whole composition together.

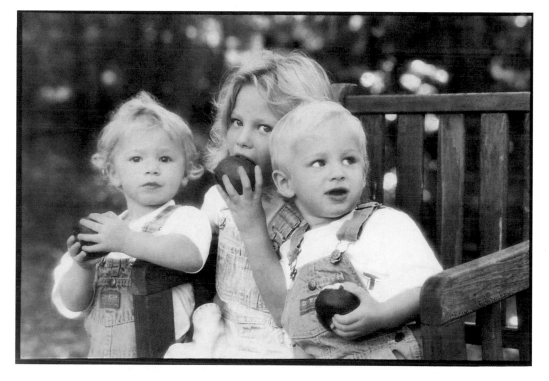

INTENSITY

Sometimes called *chroma,* the term *intensity* refers to a hue's strength, brightness, or purity. The brightness of a color is often relative to the surrounding colors. A red dress, for example, can seem more or less intense than the red of a ball next to it. To reduce the intensity of a color, dilute it with extender or add a neutral shade of gray of the same value or a touch of its complement to it. To increase the intensity of a color, use the paint straight from the tube or place that color next to its complement in a composition. In his book *A Color Notation* (Munsell Color Company, Inc., 1946), color theorist Albert Munsell recommends "balancing hues with their complements, values with their opposite values, intensities with opposite intensities, areas of strong color balanced by weak (low intensity) color, large areas balanced by small, warm colors balanced by cool colors."

In handpainting, the intensity of the pigment hues must follow the logic of the picture and correspond to the values of the photographic gray scales. The darkest areas of a photo should receive the most paint at its purest chroma saturation (straight from the tube), whereas the highlights should be light washes of paint (heavily mixed with extender). Mid-range grays of a photo should receive a mid-range intensity of paint. A higher-contrast print (containing true blacks and whites, and little gray) calls for stronger color values and intensity.

PURPLE BROWNSTONES, NYC

This low-key print was perfect for my interpretation of a romantic city street with timeless magic and saturated color. Fantasy deep purple, rich green, and soft blue. Half cartoon, all New York City.

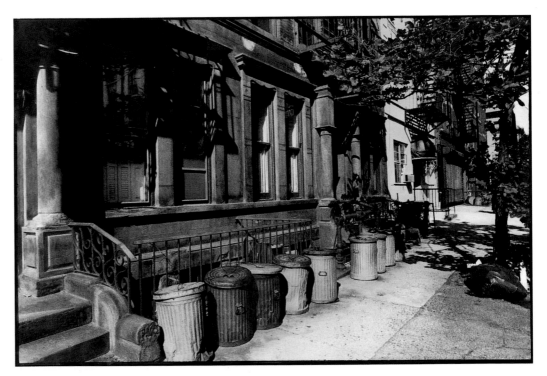

A *high-key* photograph, which consists primarily of light and middle gray values, benefits from the use of pigments that are lighter in value, and lends itself beautifully to capturing poetic moments (see the image below). A *low-key* photograph, on the other hand, consists primarily of black and dark gray values, which often create a dramatic mood. As in the photo opposite, low-key images work well with rich, saturated colors, and when you are handcoloring only certain elements of the photograph.

NICOLE IN CONNECTICUT, AGE 5

For this high-key print, a light wash of blue fills the sky, pale yellow highlights the hair, and soft violet colors the clothing. Since the gray tones of the underlying photograph were basically light, colors that were lighter in value were more appropriate than darker ones.

EXPRESSIVE COLOR

*K*nowing your intended visual message *before* you begin is a helpful previsualization tool, both when painting and photographing. For instance, when striving for a soft look, I might overexpose the image (when taking the photograph) and develop a light print. I'd further achieve a soft, painterly effect with my color palette.

For example, I might select three or four colors that appear side by side on the color wheel. These are called *analogous* colors, and they create a feeling of harmony when used together, more or less exclusively, in a painting. Or, I might work with a muted color scheme by limiting my use of colors. Analogous or muted colors enhance one another, contributing to beautiful hue gradations and value contrasts. The values of the selected hues add vitality and resonance to a photopainting. Due to their related or limited hues, analogous and muted color schemes often suggest a dominant mood.

Color can create a sense of time, weather, place, or emotion. It can be the subject itself, or it can be used to create abstract images. Colors, whether loud or quiet, tell a story. Patterns, repetitions, or similarities of colors and shapes help to create movement within a photograph. Always respect the power of color. As Joe Singer points out in *How to Paint Portraits in Pastel* (Watson-Guptill, 1972), "Color can overwhelm. . . . One must understand that when it comes to color less is often more—a lesson taught us by the masters but ignored by many artists."

KELSEY AND HOWIE

Muted hues of green, brown, yellow, and blue help to emphasize this gentle moment.

COUPLE AT THE BEACH

An analogous color scheme of richly saturated yellows, greens, and blues endows this relaxing seaside image with an overall feeling of calm.

Keeping this in mind, you might choose an *achromatic color scheme,* which is one that appears to lack color and be composed primarily of black, gray, and white. A predominantly dark, achromatic photopainting conveys an ambience of gloom, mystery, or despair, whereas a predominantly light, achromatic composition can create a mood of hope, spirituality, and peace.

Or, you might try a *monochromatic color scheme,* one that uses mainly one color to achieve visual harmony. Variations in the value and intensity of the one hue, in conjunction with the variations in the values of the photographic gray tones, make the monochromatic image a strong photopainting.

COLOR TEMPERATURE

As previously mentioned, colors are described either as warm or cool. Yellow, orange, and red are commonly described as warm colors—those related to sunlight, fire, anger, and even body warmth. Cool colors—green, blue, violets—are associated with shadows, water, winter, and ice. Many colors, most commonly green and violet, are considered to have both warm and cool

SARAH DOUGLAS

Though this photopainting displays an overall brown monochromatic theme, I also used green and red hues to give the background depth.

SELF-PORTRAIT #4

The blue, white, and purples of this image create an achromatic effect. The only real elements of color are the two leaves on the leftmost tree.

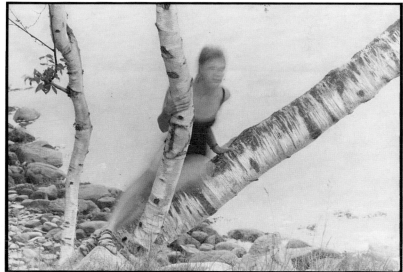

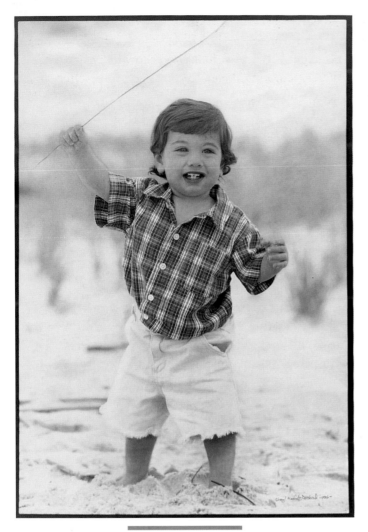

MAX WITH A LASSO

Max's shirt is a balance of warm and cool colors. Notice that I only needed a smaller amount of red to balance the larger areas of blue; it is usually the case that it takes less of a warm color to balance a comparatively larger area of a cool color.

qualities. Color temperature is also relative and variable. For instance, a warm color may appear cooler when placed next to an even warmer hue; plus warm colors appear warmer, and cool ones cooler, when contrasted with their complements. In addition, while red is usually thought of as warm and blue as cool, there are cool reds and warm blues.

Using the appropriate color themes supports the mood you're trying to create. Warm colors are associated with passion, hope, sensuality, and exuberance. Cool ones with logic, sensitivity, intellect, restraint, melancholy, meditation, and calm. Consider these associations when planning your color strategy. Also keep in mind, as mentioned previously, that warm hues move forward toward the picture plane, and cool ones recede from it. Used strategically, color temperature can create movement and mood in your photopaintings.

PSYCHOLOGICAL ASPECTS OF COLOR

Color can have psychological and emotional effects on the viewer. You can manipulate and control the mood of your photopaintings through selective color choice. Consider the most common color associations. Red is often seen as the most emotional color; it is associated with excitement, courage, ardent love, fire, and, in its most ominous sense, with sin, cruelty, and violence. Yellow, the lightest of colors, is often associated with happiness and divine love, and is considered a cheerful color. In its evil sense, though, yellow signifies cowardice and deceit. Blue denotes wisdom and serenity. It is also associated with constancy, loyalty, and peacefulness. Often, blue can be seen as symbolizing virtue or purity in a sense; for example, in paintings and altarpieces of the Italian Renaissance, Mary is always dressed in a deep, almost royal blue. For some, blue also represents a certain elegance and maturity—especially, say, a navy blue. The adverse aspect of blue is its sense of despondency.

Among the secondary colors, green is associated with fertility, and in its negative sense symbolizes jealousy. Violet and purple symbolize royal sovereignty and dignity, and are also often associated with magic. Orange is similar to yellow in its associations. Knowing these aspects of the different colors will enable you to use these effects to further emphasize the statements of your images.

PARK BENCH

Through the use of blue, this image conveys the sense of cold appropriate to the subject matter. To emphasize the chill, I also added light patches of cool violet and cool yellowish-green to the snow on the ground and the bench.

SELF-PORTRAIT #3

In this image, I left the subject (myself) and actual flowers in their original black-and-white state. I added color only to the shadows, background, and table to heighten the drama of the moment and emphasize the composition.

VALUE PAINTING VS. COLORIST PAINTING

As a handpainter, there are two styles of painting techniques that you should consider when exploring and developing your visual voice: value painting and colorist painting. The former is a style in which the artist paints all the values of color to create a study of light and shadow. In this way, a feeling of three-dimensionality is achieved by defining shapes through the contrasts of tone, value, and color. Colorist painting is a style in which the painter uses flat, saturated colors without expressing shadows. Here, a feeling of two-dimensionality prevails.

Vincent van Gogh (1853–1890) and Edgar Degas (1834–1917) were value painters. Look at their works and see how many colors there are in the highlights and shadows. Van Gogh especially used color to express his mercurial personal emotions, and his paintings embody a study of light and shadow. Henri Matisse (1869–1954) and Paul Gauguin (1848–1903) were colorist painters with the emphasis being on creating forms with well-defined shapes of color.

EAST 79TH STREET

At first glance this building simply appears red, but on closer inspection, you can see the many hues that were actually applied, including orange, yellow, and brown. These rich details and nuances of color, in both the highlights and shadows of this image, identify it as a value photopainting.

After you become familiar with the handpainting process, you'll probably decide which style of painting and color representation you prefer. I tend to be a value painter and enjoy the subtle and often complex nuances of color. Where some people see only brown, for example shoe polish brown, I see sepia, ochre, burnt umber, raw umber, moss green, and yellow ocher. I see not only colors, but paint pigments and values as well. Following in the value painter's tradition, I work with an entire spectrum of colors, building up form and contrast in my subject matter with a variety of hues, values, and intensity. Over time, you too will determine what works best for you.

The world of color is an exciting sensual place. Notice how the light hits the trees. Really study a familiar scenic backdrop. Pay attention to the color of people's clothing on the subway. *Be* in the world, and *see* your world. This will undoubtedly lead to richer handpaintings. As you begin to paint, keep in mind the words of Vincent van Gogh who said, "I study the colors of nature so as not to paint senseless colors."

MICHAEL AND LINDSEY

Candy color applied in a flat manner emphasizes the playful, dreamlike quality of this photograph and also identifies the final painted result as a colorist photopainting. There is no rendering of subtle values in the shadows, with the exception of a splash of pastel color wash on the garage wall to the right.

PREPARING YOUR PHOTOGRAPH FOR COLOR APPLICATION

No Trace. When you do something, you should burn yourself completely, like a good bonfire, leaving no trace of yourself.

—*Shunryu Suzuki*

*P*reparing your photograph for color application is a five-step process that readies the print for color application while simultaneously fortifying your mind set. It incorporates spotting, masking, assembling skewers, arranging the color palette, and priming the photo. These repetitive, often meditative, steps focus and calm the mind, offering you the opportunity to muse, connect with your photograph, and gather your inner visual and spiritual resources before diving into the world of handpainting.

For Shunryu Suzuki, "burning yourself completely" means quieting your mind so that you can fully attend to your surroundings, in this case the world of handpainted photography. Usually, our minds are thinking several different thoughts simultaneously. We're always trying to figure out the next three steps, instead of concentrating on the task at hand. Thoughts such as, "I don't want to mask the photo. I wonder what these picture will look like? I can't wait to finish," run constantly through the mind. We always want to be prepared, to be in control. Quieting the mind connects you to the magic of creating, to the artist or uninhibited child within who wants to explore the world without restrictions.

Handpainting, like all art forms, requires a leap of faith. There's a certain element of chance and spontaneity, both metaphysically and materially. Such elements as paper emulsion, humidity, paint quality and even your frame of mind at the time can all affect the outcome of your artistic endeavors. Being in the moment, walking into the fire, centers you and enables you to deal with chaos.

AMANDA AND ALICE

Every photograph must be properly prepared prior to painting, but you can camouflage any slight imperfections missed in the retouching process with color. To do this for this image, I used alternating shades of green in the foliage.

There's a logic to the order of the preliminary steps defined here. Even though you're eager to paint, you must approach the entire process with patience; you'll be painting soon enough. You must first carefully prepare your images for color application. The importance of being in a properly focused state when you begin cannot be overstated. It is only from this quiet state of mind that you can visualize your photograph and actually connect with your own artistic and creative nature. And, it is only with proper preparation that you can transform a photograph into a successful photopainting. So, make sure you execute all the preliminary steps *before* you begin painting.

RACHEL AND LEE

White spots are the easiest to eliminate. Choose the appropriate tone of gray spotting agent, and using a fine-tipped brush, simply dab or dot the paint onto the white spot little by little until you completely cover the mark. While some scratches may require more skill to cover, the method remains the same.

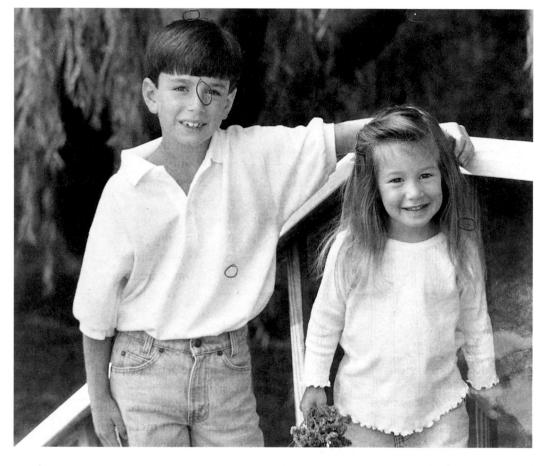

SPOTTING THE PRINT

*T*he first step in the preparatory process, spotting is a retouching technique in which imperfections on a photograph are corrected. White marks, surface scratches, unwanted lines, and harsh highlights can all be fixed with spotting. It is often a necessary process, because no matter how careful you are in the darkroom, or how professional the caliber of your photo developing lab, spots do occur and fine-tuning is essential. Additionally, it is wise to paint on a high-quality spotted photograph, due to the transparent nature of the paints and colored pencils used, because any blemishes left uncorrected will remain visible on the finished handpainted image.

I spend approximately 30 minutes to two hours spotting one photograph prior to handpainting it. I approach the process as if I were on a date; I get to know my picture, studying its highlights, shadows, and tones, and recognizing its imperfections. Grain by grain, this detailed scrutiny creates an intimate connection with my photograph while simultaneously affording me reflective time for painting inspiration.

MATERIALS FOR SPOTTING

You can use the spotting technique on most black-and-white photographic paper, however I find that fiber-based matte-finish paper yields the most successful correction results. It allows the spotting dyes to penetrate into the emulsion of the photograph without leaving a visible residue. Spotting efforts on gloss- and semigloss-finish paper, particularly the resin-coated varieties, tend to show the spotting corrections. If you're working on resin-coated paper, use only a spotting solution—not watercolors—and use it carefully with a well-blotted, semi-dry brush.

You'll need the following materials for spotting: spotting dyes; tin watercolor cups or a mixing palette; a cup of water; blotting paper (paper towels work well); paintbrushes (two to three fine-tipped, sable-bristled ones); and gray, black, and all-surface pencils. There are several brands of spotting dyes to choose from, including Spot-All, Spotone, Marshall's Liquid Retouch Colors, and SpotPen (see page 35 for a picture of all these materials). I generally use Spotone and SpotPen sets. Spotone is available in three- or six-color sets, and SpotPen is available in sets of ten premixed colors. The pens have fine tips, equaling a #000 sable brush, although the tips are nylon. SpotPen sets are available in tones for both warm-tone and cold-tone paper. You can buy spotting liquids and pens at photographic supply stores and at specialty art stores (see the Resources section on page 143). If you're working on fiber-based paper, you can also use watercolors for spotting.

WORKING METHODS

To create a spotting palette when working with liquid spotting agents, use tin watercolor cups or a palette with individual wells for separate colors. Label each cup or well according to the corresponding dyes used. For example, when using the Spotone three-color set, I label three cups, each with the respective dyes: #3, #1, and #0. Placing a few drops of the corresponding dyes into the labeled tin compartments, I allow them to air-dry for approximately 24 hours. Once dry, they're quite easy to control and enable easy mixing of new shades to best match the image and base tone of the photograph. When you use Spotone, the dyes will be wet (unless you wait a day after preparing your palette).

To mix a new shade of a spotting dye after you've let your palette dry overnight, dip a fine-pointed sable brush (#000 is a good choice) into a small cup of water. Touch the wet brush to the dry dye, taking a bit of the color and depositing it in an empty cup or well on your palette. Do the same for another dye, and mix the two together. Use your paintbrush to add more water to the mix until you've diluted the new dye to a value slightly lighter than the tone of the print. To apply the dye to your photograph, rinse your brush and dip it into the dye. Blot the excess on a paper towel. Don't overload your brush; if you do, you'll lose control of the liquid, and the spotting effort will be obvious. A little dot goes a long way.

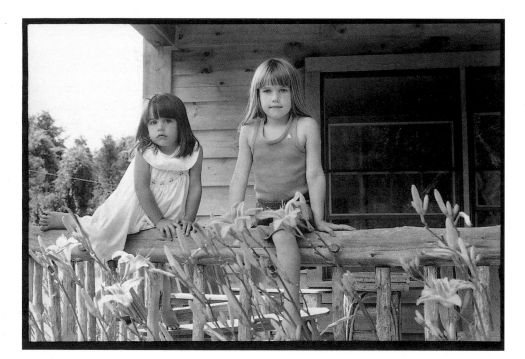

Opposite is the original print of the photopainting "Amanda and Alice" on page 60. The clothesline cutting across the trees is distracting and draws the viewer's eye away from the girls. To eliminate this element, I divided the line into five segments and retouched it dot by dot, covering the entire line one section at a time and matching the varying shades of gray in the surrounding foliage. Simply sweeping a brushstroke across the clothesline wouldn't have worked, because the line still would have remained a line; the objective here is to blend the line *into* the foliage. Since a photograph is composed of grain dots, small spots of paint (formed by a dabbing or stippling action) better mimic the grain and camouflage the line.

To achieve the appropriate spotting tones, I mixed each dye in a separate well of my palette and tested them all by touching the tip of my brush to a piece of paper towel (above right). The final retouched black-and-white photograph (below right), without the distracting clothesline, is much improved. Now, the focus remains on the two lovely subjects.

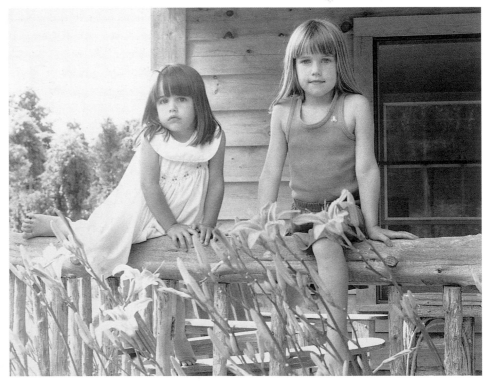

Spotting dyes often dry a shade darker than they appear when wet, so it is best that your dyes be a little light. To ensure this, I always wet my brush first, before dipping it into a dye, thereby automatically diluting the tone. I then blot the tip of my brush on a paper towel to prevent liquid overload. Working with spotting dyes (whether in liquid or pen form) is very similar in principle to painting with watercolors. Essentially, you're working with a light touch, gradually building intensity in the tone of the area being retouched. Take your time, mix appropriate dye colors, and test them on a blotter before application. Since the dyes often dry darker than expected, begin with a lighter tone and build (darken) the color dot by dot. It is much easier to build up color than to reduce the tone once it is applied.

Spotting, like handpainting, requires concentration, patience, and a light touch. The trick to spotting is working slowly, dab by dab, in a stippling manner. The dots gradually join together (like the colors in a pointillist painting), eliminating the unwanted area. Remember to always place a sheet of white paper over the areas of the photograph where your arm or hand rests, to protect against direct contact with oils from the skin (which can affect the emulsion).

To fix incorrect spotting efforts, such as dyes that are too dark, the wrong color, or otherwise incorrect, do the following. First, dip a clean brush into clean water and blot the excess from it so as to not oversaturate your photo. Touch the slightly wet brush to the incorrect area, and then blot by gently pressing a piece of paper towel onto the spot. Doing this three to five times will help lift some of the intensity of the gray dye. You can also use rubbing alcohol to dissipate spotting errors following the same procedure. These modification procedures do have drawbacks, however. Water will leave a mark on some glossy and semimatte papers (particularly on resin-coated prints), while fiber-based paper will absorb the dyes on very light-toned areas and actually stain the print, making these spots very difficult to remove.

MASKING THE BORDERS

JOELLE PAINTING

Painting on an unmasked print (left) presents visualization problems. The photograph's unmasked, white border becomes dirty, can confuse the painting process, and ends up being visually distracting. However, when you mask the print (right), you can view your image against a clean, white border, and can visually focus on, and correct, subtleties of color, value, and tone.

*M*asking is the second preliminary step when preparing photographs for color application. It is a method of protecting certain areas of a photo from receiving unwanted paint and primers. For handpainting purposes, you only mask the borders of the photograph, because you'll clean other areas on the photograph of any unwanted color throughout the painting process, using either extender or Marshall's Marlene chemical solution. Masking specific areas in the actual photographic image results in obvious, harsh edges and is not recommended. Masking the borders of your prints, however, is helpful because clean borders provide a neutral margin against which to judge color harmony and intensity during color application. Colors that look slightly off will jump out at you against the clean white borders that frisket so easily provides, and you'll then be able to correct those hues.

The materials required for masking are frisket, an X-Acto knife, a cutting board, and a straight edge or ruler. Frisket is a masking agent available in liquid and film forms. The film form is a low-tack (easy to lift) soft, transparent, peeling film that comes in a variety of widths on rolls or flat sheets. If you're using frisket film, you'll need a straight edge, knife, and cutting board for cutting the film; I recommend working with a #11 X-Acto blade and a triangle. Frisket is available in glossy and matte finish, and either one is acceptable for handpainting. There are several brands on the market, and you can purchase them at most art supply stores.

While it is possible to clean the borders after painting with solvents, such as turpentine or Marlene, there are a number of advantages to using frisket. Perhaps most importantly, it is better to avoid using chemicals whenever possible. In addition, frisket is simple to manipulate, and its methodical use creates a contemplative atmosphere for previsualization (an essential aspect of the handpainting process); like all the preliminary steps, masking provides quiet time for insight. Furthermore, frisket achieves clean white borders efficiently and rapidly, and a clean white border is most desirable for final presentation.

To cut frisket film, lay a piece of the film on your cutting board. Using a triangle, ruler, or other straight edge, cut the frisket in four strips that approximate the size of the white borders on your photograph. Remove the paper from the back of the film, and lay the frisket strips on the border, carefully lining them up to the edge of the image. Be as precise as possible to ensure the proper masking of the photo. I usually print my photographs full-frame with a black border. The black border is part of my signature style, and it also makes masking very easy because it facilitates lining up the frisket film against the edge of the image.

After the frisket film is aligned and in position, lightly sweep your hand across the film to ensure proper adhesion to the print. After you finish painting the image, simply lift a corner of the film and gently pull away the strips. The beauty of frisket is that, unlike masking tape, it won't damage the photograph on removal.

SKEWERS

The handpainter's "brush" is a skewer or toothpick with cotton wrapped on a pointed tip. These are essential tools for applying paints to photographs. Skewers themselves are wooden sticks (without cotton), like toothpicks only larger and thicker. They're approximately 4½ inches long and can be purchased from restaurant suppliers, specialty art supply stores, and mail order catalogues (see Resources). Common household items, such as bamboo sticks or food skewers also work well as handpainting skewers. In fact, you can use any wood stick with one pointed end for handpainting. Blunt-tipped sticks won't work.

To make wrapped skewer handpainting tools you'll need skewers and rolled cotton, like that available for medical purposes. (See photo below.) Machine-wrapped cotton swabs are inferior, and I don't recommend using them; the loosely wrapped cotton provides little control during paint application. Generally, the 4½-inch wrapped skewer tools work well for overall paint application, and smaller versions made from toothpicks work well for rendering fine details, such as lips, foliage, and clothing. I stock three sizes of wrapped handpainting skewers in my studio: 4½ inches, 4 inches (which are long toothpicks), and toothpicks (the regular size).

You should always keep a large quantity of skewers on hand—at least 100 or more of each size—along with a substantial amount of 100 percent rolled cotton. Then, whenever you need to make new skewers, you'll already have all the materials you need. Note that using fresh sticks results in the best adhesion of cotton to the sticks, because at first the sticks have a rough surface. After handling, they become smoother and the cotton tends to fall off. In addition, fresh skewers have the strongest tips and this is helpful in manipulating the paints on the photograph.

When wrapping your skewers, use only top quality 100 percent cotton in rolls, rather than cotton balls. The thickness and tightness of the wrapped cotton will determine the size and effectiveness of the tool. A skewer wrapped with a thin sheath of cotton is good for executing fine details, whereas a skewer wrapped with more cotton is better suited for applying a general paint coverage. The ease and success of your handpainting depends directly on the craftsmanship of your wrapping.

The 4½-inch wrapped skewer is my workhorse. The thicker skewers rarely snap while applying pressure during paint application. In addition, the length provides freedom of movement across the photograph, enabling easy coverage of large areas. This size is also easy to wrap, and I can attain various thicknesses of wrapping, creating a wide array of tools. Toothpicks are more useful when working on small prints. Their compactness aids with the fine motor skills required for handpainting. Wrapped tight and thin, toothpicks are excellent for rendering details and lend an element of control to the painting process.

HOW TO WRAP SKEWERS

The following photographs illustrate step-by step how to wrap a skewer. I recommend wrapping many skewers, and in different sizes, prior to handpainting. About seven to ten large skewers and five toothpicks should be adequate. Just as traditional painters have many brushes at their fingertips, you should also have a variety of tools at your disposal, giving you more options as you paint. Having your skewers ready is an important preparatory step. This readiness allows for spontaneous work. Interruptions are frustrating and counterproductive.

Each skewer is used for only one color application, so make enough skewers to cover all the basic colors with which you intend to work. For instance, if you're painting a portrait, you'll need one wrapped skewer for the flesh tones, one for hair, one for the background, and at least two for clothing. You'll also need toothpicks for the facial details, the hair, and details in the clothing. Unlike a painter's brushes, which are washed and reserved for the next time, skewers are discarded at the end of a painting session. The tips of the skewers, and especially of the toothpicks, become worn and saturated with paint. Always start with new skewers for a new image.

When wrapping, keep the following things in mind: 1) use only a touch of saliva; 2) wrap the skewers tight with a gentle touch; this is the trick to making effective skewers; 3) too much cotton won't roll well, and cotton rolled too loosely will fall off during painting; and 4) the cotton must cover the tip of the skewer completely, otherwise the wood will scratch your photograph—if the tip is exposed, pull off the cotton and reroll it. I'd suggest practicing rolling for 10 to 20 minutes to get the process down.

1. To wrap a skewer, I take a large clump of cotton and bring it to a clear area in my work space. Holding a skewer in my writing hand (my right), I bring it to the edge of the clump of cotton and pull apart a small strand. The amount of cotton that I pull out determines the thickness of the final wrapped tool.

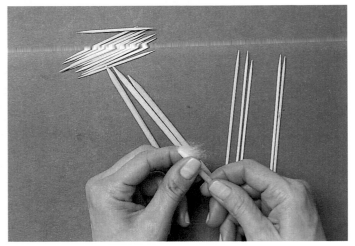

2. While holding the strand of cotton around the pointed tip of the skewer with my left hand, I twirl the skewer with the middle finger and thumb of my right hand. As the skewer rotates, I gently but firmly guide the cotton onto the tip of the skewer using the thumb and index finger of my left hand. I continue twirling and guiding the cotton with my fingers until the skewer is completely wrapped, making sure to apply firm pressure to the last threads to ensure that they stick firmly in place. Note that you don't need any adhesive for this; the cotton will adhere to the skewer on its own.

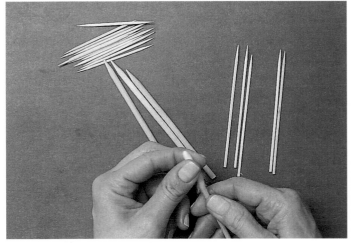

3. I make sure the last threads are secure to avoid having the cotton unravel as I apply paint. Sometimes, if I'm experiencing difficulty getting the cotton to adhere to the stick, I lightly touch the thumb and index finger of my left hand (the hand *not* holding the skewer) to my tongue. The saliva helps the cotton adhere better to the wood, and just the right amount will help roll the cotton into a tight handpainter's "brush."

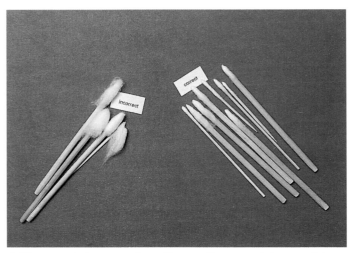

4. When comparing correctly and incorrectly wrapped skewers, it is easy to tell the difference. It may take a little time, but with practice you should master the technique.

ARRANGING YOUR COLOR PALETTE

*T*his is the next step in preparing for color application. Having spent some quiet time spotting, masking, and making a supply of skewers, you should be well acquainted with your photograph and have some visual inspiration. You're now ready to set up your palette. You can use wax paper or disposable paper palettes for handpainting, and these are available in art supply stores in pads of various sizes. When you're done with one palette, simply tear the top sheet off and throw it away. A medium-sized pad (11 × 14 inches) works well, and you should have a clean palette sheet ready before you begin putting down the paints. I recommend wearing disposable vinyl gloves for setting up the colors, because the paints often find ways of oozing out from the sides of their tubes, making a mess. The gloves prevent unnecessary contact. I usually need two pairs of gloves just for this preliminary step, because the paints get so messy.

Marshall's oil paints are rich, so you only need pea-sized dots for one work session. I arrange my colors on the palette in groups of color categories, such as all the flesh tones in one area, the reds in another, blues in another, greens in another, and so on. (See pages 78, 81, and 93 for other examples of palette arrangements.) Organizing the palette this way is in keeping with the methodical philosophy of the five-step preparatory process. In addition, grouping my colors by hue category helps me visually determine, in an instant, which color will work best for a particular image or element. Grouping all the flesh tone colors together also facilitates color mixing. Instead of looking for my colors on the palette, I know exactly where they are.

Place a small amount of every color you think you'll need on your palette. If you have a lot of paints, don't lay out every color you own. Study your photograph, think about the colors you'd like to create and which paints you'll need to mix them. Then, lay out only those colors. Too many choices will be confusing and wasteful.

Although paints can be reused over the course of a two-day period, I find a fresh palette produces a cleaner photopainting. If you must leave your work in progress to continue at a later time, simply store the palette in a safe place (away from people and pets), or throw it out and begin a new one. Remember, you're using pea-sized dots of paint, so the waste will be minimal. When reusing a saved palette, you may find that a hard crust has formed over some of the paints. Simply take a skewer and push on the crust, and the paints will ooze out from the sides. My rule of thumb is that if I'm stopping for only a few hours, I reuse my palette; if I will be away longer than that, I throw it away and reset my palette at the beginning of my next work session. Once you have set your color palette, you can proceed with priming.

PRIMING THE PHOTOGRAPH

*P*riming a photographic print chemically alters the paper surface, readying it for paint application. Priming enables the fluid and gentle movement of paint across the paper surface. The primer creates a barrier that prevents the paper from completely absorbing all the paint, and this allows for a controlled layering of pigments. Generally, it is easier to handpaint on a primed photograph than on an unprimed one. A liberal coating of primer allows for a more fluid work session. To prime a photograph, you'll need the best-quality rolled cotton, soft tissues (without any softening additives, such as oils and aloe), and Marshall's P. M. Solution. Use only good-quality tissues, because you don't want to scratch your print.

As you become more familiar with the medium of handpainting and with your preferred paper choice, you'll discover the many nuances, and discretionary uses, of priming. For example, some photographic papers need priming more than others, and some papers or painting styles don't require it at all. Typically, glossy papers don't need a primer (although I don't recommend handpainting on glossy paper). Matte-surface fiber-based papers benefit from primer, and colored pencil applications require the use of primer, regardless of the paper surface. Primer isn't always necessary on matte resin-coated papers—some of them are slippery enough without primer. Experience and experimentation will guide you here.

The painting style and size of the photograph also dictate how much priming is necessary. As a general rule, to achieve strong color saturation on small prints, use a little primer and rub it in hard to attain the most control in your paint applications. When working on prints 16×20 inches and larger, always apply a primer.

HOW TO APPLY PRIMER

To prime a photograph on matte paper, take a clump of cotton and saturate it with Marshall's P. M. Solution. The solution is a mixture of turpentine and vegetable oil and has a strong odor, so exercise caution when using it. Work only in a well ventilated room, and as an extra safety precaution, discard used pieces of cotton and tissues immediately. To begin, start at the top of the photograph and sweep the saturated cotton horizontally across it. Then, sweep it across the print again vertically, to really lock in the oils. Check that you've covered the entire picture surface by bringing your eye down to the level of the print. Due to the oily nature of the primer, you should be able to tell whether or not you've applied it uniformly. If you missed a spot, go back and reapply.

Next, take a tissue and rub off a light layer of primer. Note that how hard you rub affects the amount of primer left on the photographic surface and, ultimately, the ease of paint application. With practice, you'll develop the right touch for your particular style. (You may like the wet effect of not rubbing down at all, or perhaps you'll opt to work on a dry print.) At this point, the photo is ready for painting. A first coat of primer is typically good for 24 hours. After that, a second application may be necessary. If you use Marshall's Marlene during the painting process, that solution will lift the primer off the print and necessitate reapplication of primer to proceed.

To prime your photograph, saturate a piece of cotton in primer and then, beginning at the top of the print, sweep the cotton across the picture, first horizontally and then vertically. After doing this, check that you've covered the entire picture surface; if not, reapply.

PRIMING GLOSSY PRINTS FOR PAINTING

*W*hile you can spray photographs printed on glossy paper with a spray primer, I don't recommend this. The matte-finish spray primers are toxic—it can be scary just reading their labels. It is better to print your photographs on a matte-surface paper and avoid the use of these chemicals. However, if you must work with glossy paper, I suggest using a matte-finish spray primer, such as those by McDonald or Marshall's, to prepare the surface for color application. Apply it outdoors, and consider wearing a surgical mask, as well.

Spray the print vertically and horizontally to lock on the matte finish. It will dry within minutes. Note that this applied matte surface will be vulnerable to easy removal and chipping. Also, don't use Marshall's Marlene on sprayed prints—it will lift the matte surface off—and be very careful when working with pencils and skewers. Chipping of matte spray primer with pencil points is a common occurrence.

FIFTH AVENUE WITH MAILBOX

So much time and energy went into creating this snowy New York City scene, yet if you look carefully, you can see where the matte-surface spray primer and the paint have chipped off in the right foreground (see the circled area). To avoid risking damage to your work, it is better to paint on matte-surface paper, rather than spray glossy paper with unreliable matte spray primer.

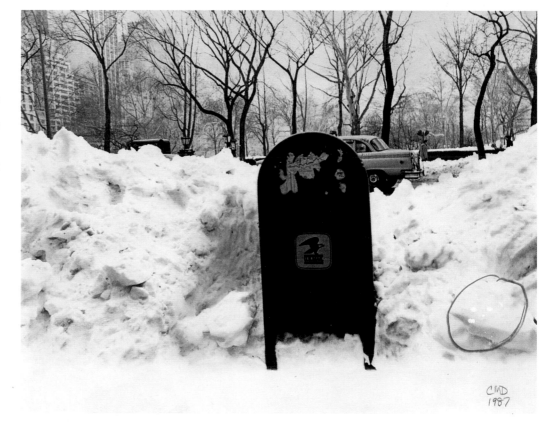

THE BASIC PAINTING PROCESS

I exaggerate the fairness of the hair, I come even to orange tones, chromes, and pale lemon yellow. . . . I make a plain background of the richest, intensest blue that I can contrive, and by this simple combination of the bright head against a rich blue background, I get a mysterious effect, like a star in the depths of an azure sky.

—*Vincent van Gogh*

I work on two levels. I try to construct a picture in which shapes, spaces, colors form a set of unique relationships independent of any subject matter. At the same time I try to capture and translate the excitement and emotion aroused in me by the impact with the original idea.

—*Milton Avery*

These observations from Vincent van Gogh (1853–1890) and Milton Avery (1885–1965) provide a glimpse into the aesthetics of two world-renowned painters whose works, though thoroughly diametric in terms of style and artistic vision (the former is a colorist, the latter a value painter), exemplify the painting process. Through their words, we can see that van Gogh and Avery both had a game plan—a strategy in which they used color, shape, form, and composition to express an artistic statement.

For the handpainter, as well, the creative process begins with a clear understanding of one's intentions, one's *planned artistic statement*. The actual painting process is then organized to support this central goal, through the use of color scheme and personal painting style, to achieve the artist's visual message. Your own style will develop with practice, but first you must discover how to work within this elegant visual medium. In this chapter, the first introductory step-by-step lesson (on pages 82–91) shows how I created the portrait of Max (opposite) and presents all the basic elements of the painting process.

MAX

The strength of this image is based on its overall subtlety, which allows Max and his wonderful smile to dominate the space.

SETTING YOUR PALETTE

*K*nowing your intentions is critical to achieving a successful handpainted photograph, especially a portrait. Portraiture communicates an essence of the person. The eyes, body language, and setting all work together to tell a visual story. The goal of a portrait is to emphasize the personality of the subject *and* evoke an emotional response from the viewer. Just as a relationship must exist between the photographer and subject in order to make a good photo, a relationship must exist between the handpainter and the photograph to make a successful photopainting.

Knowing your subject is important, because you can then use color to communicate with the viewer. For example, you might use very little color to emphasize the documentary aspect of a portrait, and not diminish the power and integrity of the photograph; or, you might use a rich, warm color palette to emphasize a subject's strong, larger-than-life personality. Used correctly, handpainting can create or heighten atmosphere, and provide visual dialogue and ethereal qualities. However, if you don't know your intentions, you won't be able to make the appropriate color decisions.

Consider why you're handpainting a particular photograph. Familiarize yourself with your objective. Ask yourself the following: What is my goal in handpainting this photograph? Who is it for (if anyone)? Was I commissioned by someone to paint it and do I therefore have a responsibility to represent the subject in the most flattering light? What am I trying to say? Do I want to create a pleasing image or startle the

This is the palette I used to create the portrait of Max on page 76. When I prepare my palette, I consider which colors to use and then organize all my paints (which are labeled in the photo for clarity) neatly in pea-size dots, placing the flesh tone hues near one another for mixing convenience. In this case, I used a total of six different colors plus extender. Before beginning, I also make sure I have ready all the colored pencils I plan to use.

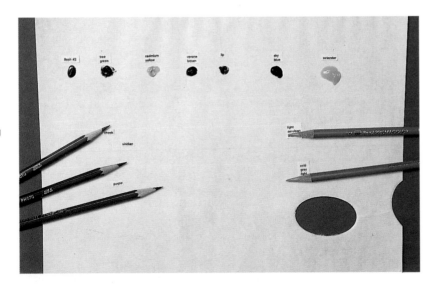

viewer? Is the image nostalgic? You will answer these questions with the colors you select for your palette. This disciplined approach to setting up your palette provides a strategy for focusing on your photograph and applying paint to it meaningfully. Sit quietly and look at your photograph. Let it inspire you. Notice the light source and the direction of the light and shadows in the image. Visualize different colors. Imagine the finished work. Once your vision is clear, begin setting your palette.

MAX

This is the original black-and-white print for the photopainting on page 76. Before starting to paint, I always consider the black-and-white photo, along with my motivation for handpainting a particular image. I try to determine my color palette and overall visual goals so that I have a game plan to follow during the painting process. In this instance, I was commissioned by Max's mother to create a portrait for her that made Max look adorable. My responsibility, therefore, was to render a true resemblance of Max in the most flattering and charming way possible.

Mixing Colors

*A*fter you set your palette and define for yourself the task of visual interpretation, the handpainting process begins to unfold. You now know what you're trying to say with your photopainting and which colors you need to do it. For an image such as the one of Max on page 76, I knew I needed both a blue-green color for the ocean and a khaki color for Max's pants, among others. So, as an example here, I'll specifically address the color mixing process involved in creating those hues.

To create blue-green, I mixed Marshall's brand tree green pigment to their sky blue. Marshall's Introductory Set often includes Chinese blue, and this hue would also have worked in the mix. A wash of this color worked well for the sky (see page 88), and the addition of more green to the mix created a blue-green ocean color. If a hue you've mixed looks wrong to you, simply add more of one color or another to adjust it. I could have added more green to the blue, or even created a new green by mixing blue and yellow. For a khaki hue, I mixed Verona brown with tree green. Note that to dilute the chromatic value of my hues, I mix them with extender, and I always test my color mixtures on a scrap photo first, before applying them to the actual work.

Flesh Tones

These are perhaps the most important, and often the most complicated, colors with which to work. In a portrait, the subject is a significant element; therefore, the success of the photopainting depends on a flattering rendering of the face. This rendering, in turn, is dependent upon three factors: a complementary flesh tone, the photographic quality of the subject (remember the oil paints are transparent so the photo will show through them), and the application of the facial hues.

While there are paint colors called "flesh" available, a personal blend of the appropriate hue is usually far superior and worth the time and struggle to create. You can mix virtually countless shades of flesh tone and are limited only by the number of paints you own. However, even with a limited number of colors, you can produce a beautiful flesh tone. Learning the color nuances and mixing proportions will come with experience, but the basic formula for flesh tones is to combine red and yellow in equal proportions, and then add brown and green, a little at a time until you get the desired color.

Mix the colors with a wrapped skewer, bringing a little bit of each color together on your palette. Turn your skewer in a circular motion to blend the paints. Adjust the mixture, if necessary, by adding red (if the mixture is too yellow) or brown (if the mixture is too red). Using different colors and proportions in the basic formula will alter

the mixture, resulting in an array of varying tones and subtleties. For example, cheek (a red pigment) plus cadmium yellow plus Verona brown plus tree green yields a different flesh-colored hue than a mixture of carmine (a different red) plus cadmium yellow plus Verona brown plus tree green. (All of these color names refer to Marshall's paints.)

A large percentage of brown mixed with smaller proportions of red, yellow, and green will create a dark flesh shade. A heavy concentration of red produces a redder color. Experiment with as many combinations and proportions of reds, yellows, greens, and browns as possible, mixing a little of this with a little of that until you achieve a blend that looks right. Test your mixture on a scrap photo. Once you discover the recipe for the most appealing hue for your portrait, any future portrait work becomes easier. Of course, the shade of the flesh tone depends on the subject. Use the following guidelines: for children, use more red; for African American skin try a larger percentage of browns and reds; for Asian and Native American skin try a mixture that contains more yellow.

The subject's tonal value (where the subject falls on the photographic gray scale) also affects the flesh coloring. Subjects in shadow often require additional (or darker) layers of color to darken the image (remember these oil paints are transparent). I applied the balance of colors utilized in the portrait on page 76 straight from the tube thinned with extender. I also used colored pencils, as well.

These are examples of just three of the many possible flesh tone mixing combinations. Be daring and experiment with as many as you like. (All color names refer to Marshall's brand paints.)

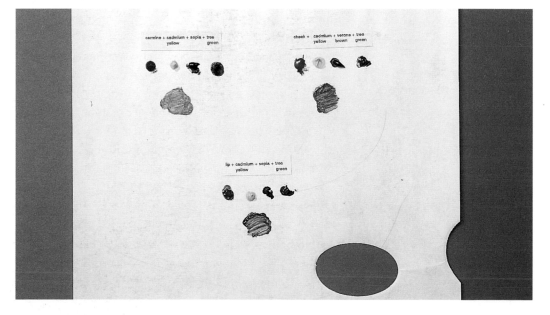

carmine + cadmium + sepia + tree
yellow green

cheek + cadmium + verona + tree
yellow brown green

lip + cadmium + sepia + tree
yellow green

PAINTING A PORTRAIT, STEP BY STEP

*T*here's an orderly and systematic approach to painting a portrait. Following this logical approach minimizes confusion and increases your chances of success. The basis of this process is that you paint the most important elements of the image first, and the most important element of a portrait is the subject. You apply the subject's flesh tone first, followed by the hair and facial details. Background colors follow in the sequence, and clothing is one of the last things painted in order to create color harmony with all the previously painted elements. Together, all these visual components serve to highlight the subject.

There are two reasons for painting the subject first. First, achieving a successful rendering of the subject provides immediate gratification in an otherwise slow-moving, time-consuming process. This reinforcement then sets the stage for a positive overall painting experience. Second, working on a clean photograph enables you to produce the most flattering flesh tones. It is always better to work with flesh tones before applying any cleaning solutions to the photograph. (See page 38 for more information on the use of cleaning solutions.)

Once you're satisfied with the subject's skin tone, hair, and facial features, you can move away from the subject to the top of the photograph, and work methodically downward. Painting from top to bottom protects against accidental smearing of any previously applied paints; instead of starting at the bottom of the image and then leaning over (and possibly smudging) those painted sections as you move toward the top, start at the top and work your way down. As a protective barrier, place a sheet of white paper over the areas on which your hand rests.

The nature of light also supports the notion of working from top to bottom, and light is an integral factor in a handpainter's work. Make a formal determination of the lighting conditions in your photograph at the outset of the painting process. For example, at what time of day was the photograph taken and what were the weather conditions? Each color that you apply should complement those conditions. A fall day at dusk evokes a different color scheme than that of a summer morning. The hue and intensity of the sky affects all the hues and their intensity throughout the handpainting process.

For the photograph of Max here, I envisioned a hazy morning. I therefore wanted to use a sky blue color in my painting. This soft, muted coloring affected all my subsequent color selections, because I had to balance the ocean, sand, and clothing equally to achieve the overall soft look appropriate for a young child.

The method for painting a still life follows that just outlined for portraiture. For landscape images, also begin at the top of the photograph and work downward. This approach incorporates the significance and natural movement of light as it sweeps across the picture plane. In the next few sections, using my portrait of Max as an example, I'll walk through the painting process step by step, and also through my thought processes and goals in creating this portrait.

APPLYING SKIN TONES

As explained above, you should always begin a portrait by applying the skin tone. Start with the face and then move on to any other body parts. Apply the paint in a circular motion, and don't worry about the color running onto the background areas. Painting "outside the lines" is inherent in this process, which is called creating a "wash." If you're not pleased with the results, simply apply a second coating of flesh colored paint. When you're finished adding the skin tone, save the skewer for later use, placing it on the edge of your palette.

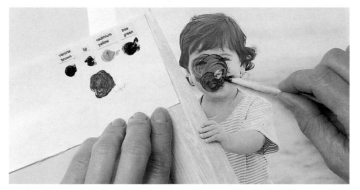

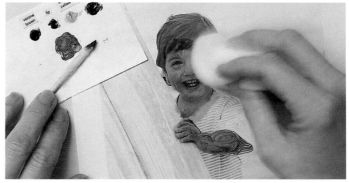

1. For this portrait, I want to focus on Max's natural adorableness. This means creating a realistic, rosy childlike flesh tone to maintain his innate babylike quality. To do this I mix Marshall's lip red, Verona brown, and a yellow color in basically equal proportions, and then add a dab of green.

I apply this flesh mixture to all the appropriate areas of the photograph using a tightly wrapped skewer. I cover the tip of the skewer with paint, being careful not to overload it, and apply in a circular motion. This style of application helps achieve an unmottled, natural layer of color and is the best way to cover most areas on a photograph. At this stage, I don't worry about the paint running into the hair, eye, sky, or sea areas.

2. To blend the flesh tone, I take a clean clump of cotton and barely skim the surface of the print with it. I continue gently wiping the cotton over the print until the flesh tone is well blended. Note that the more pressure applied, the more color lifted. (When I first learned to handpaint, everything I put down came right off on the cotton. It was very frustrating.) Note that I always place used cotton immediately into the trash. Accidentally using dirty cotton on the photo would make a mess.

At this point, I check the tone. If it is too light or transparent, I add a second wash following the procedure in the previous step and using the same skewer, and I rub gently again with cotton and fine tune. I also keep a bit of extender on my palette in case I need to clean any areas of unwanted paint or reduce the intensity of some of my colors.

COLORING THE HAIR

After finishing the skin, the next step in a portrait is to move on to the hair and facial details. Since my goal in this photopainting is to produce a true resemblance of Max, I want to match the colors of his hair, eyes, and lips. If, however, you're not so concerned with creating an exact or literal representation of your subject, you could exercise a bit more freedom in your choice of colors. Note that the eyebrows can be painted using a colored pencil or a toothpick applicator, and they should match the hair color. Simply follow the eyebrow contours of the photograph and blend gently with a loose clump of cotton.

Just as with the flesh tone, I apply the hair color in a tight, circular motion, moving outward following the direction of the hair until all of it is covered. (Note that if your subject is small, you could use a toothpick to render the hair.)

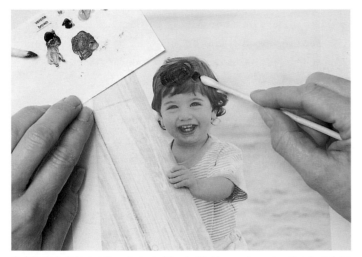

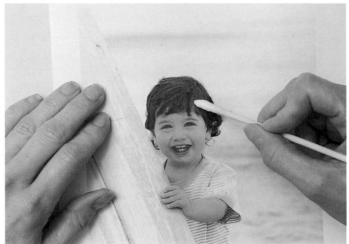

3. Max's hair is medium brown. Marshall's Verona brown, mixed straight from the tube provides the best match. (For darker brown hair, you could add a little black paint, and for a lighter brown, add a bit of extender.) Using a new skewer, I touch it to the Verona brown and twirl the tip against my palette to remove any overloaded paint. I apply the brown directly over the flesh tone paint that overlapped into the hair area; the flesh tone is lighter than the brown and won't alter the hair color. I keep the hair simple by applying a flat field of color—any hair highlights will shine through the paint when it is rubbed down with cotton.

4. After I've covered all the hair with paint, I take a clean skewer and gently sweep it across the hair area and away from the face, to blend the color. I could also use a piece of cotton to do this, lightly wisping (gently wiping) the color into a beautiful blend. However, the skewer provides greater control, usually resulting in less color inadvertently washing into the background areas. Brown will inevitably seep into the background and, while I expect this (it is inherent in the process), I also try to limit it as much as possible. Eventually, I'll clean these areas with extender before making further paint applications.

Adding Color to the Cheeks

I like to add a hint of blush to children's cheeks using colored pencil. This is, of course, totally optional, but the subtle effect is endearing. In Max's case, emphasizing his cheeks accentuates his excitement and energy, and only serves to make him more adorable, which is the effect I'm aiming for. Note: Use color sparingly here; children shouldn't look like they're wearing makeup.

After applying the color, I take a clean piece of cotton and gently wipe over the pencil to blend it, being extra careful to avoid wiping too firmly and therefore lifting up the underlying flesh tone. Just a light graze with the cotton should blend the color, but if not, I gently wipe again until the cheek pencil is blended into the skin tone. A light touch is a skill that develops over time.

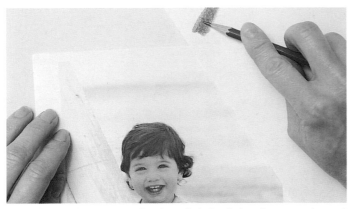 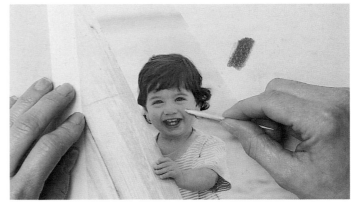

5. For Max, I choose a pencil color called cheek, but there are other red colors that would also work well. Using the side of the pencil point, I rub down hard, applying several layers of red to a white sheet of paper (not my photograph). This readies the color for transfer to the photograph.

6. I then transfer the color onto a clean, tightly wrapped toothpick applicator by pressing the toothpick against the color swatch. To apply the color to the photo, I very delicately rub the cheek area in a circular motion with the toothpick.

Painting the Eyes

I paint subjects' eyes with pencils, which provide more control in small areas than do paints. However, first I clean any unwanted paints from the area with extender. To do this, take a tightly wrapped toothpick applicator and apply a minute amount of extender to it, turning the toothpick to the side and rubbing the excess off onto the palette. This ensures that only a tiny bit of extender remains on the toothpick. Then lift the residual brown paint with the toothpick; try hard not to move beyond the eye with the extender, or the flesh tone will lift off. Take another wrapped toothpick applicator and clean off the eye again, carefully lifting any remaining extender. Do this with a clean wrapped toothpick applicator repeatedly until you're confident that you've removed all the extender.

When coloring the eyes, always select a colored pencil with a sharp point and color in the eye following the shapes in the photograph. Once the eye color is correct, clean out the areas of eye highlights with a clean wrapped toothpick. You can also render (or catch) highlights with a white pencil and accentuate the irises with a black pencil.

7. I apply a blue color to the eyes. I also often line the upper lids with a brown or sepia colored pencil to accentuate the eyes. After applying the color, I rub it down with a clean, finely wrapped toothpick applicator. If I rub off all the color, I simply repeat the procedure. After rendering any highlights, I blend by gently sweeping a clump of cotton across the area.

COLORING THE LIPS

Lip color should look as natural as a possible, particularly on men. Men's lips should never appear pink; stay with a more natural color. You can, however, use a wide range of red and pink hues to accent women's and children's lips. I find that Marshall's flesh #3 oil paint works well for lips on men of all ages, and that's what I use here for Max. Some colored pencils will also work; Prismacolor's henna pencil works well for both male and female subjects.

Lips are often tricky to color because they are such a small area of detail. To render lips more easily with paint, use a finely wrapped toothpick. Colored pencils offer an even easier method of application, although actually achieving the correct lip color is often more difficult. Try using two pencils, applying one on top of the other and then burnishing them with a clean cotton skewer to produce a good lip tone.

In general, apply lip color sparingly to avoid smearing it into the skin tone. Sweep gently over the lips with clean cotton to blend the color. It should blend with the flesh tone. If it doesn't, or if you wipe off too much lip color, repeat the process. If the tongue is visible in the photograph, as it is with Max, paint it the same color as the lips, cover with a thin layer of a red pencil, and burnish with a clean wrapped toothpick.

CLEANING UP OVER-WASHES

Before moving on and adding color to the background of your picture, you must clean up any "over-washes" of previous color that have run into the background areas. You can see in my portrait of Max that the flesh tones and brown hue of his hair have smeared onto the ocean and sand areas. To remove these over-washes, you use extender and clean wrapped skewers. Dip a clean skewer into extender and approach the edge of the subject, rubbing down to lift off the unwanted color. Turn the skewer so that you are using a clean section of cotton and continue the process. Once the skewer is completely dirty, throw it away and roll another one. Repeat this procedure until you've removed all the unwanted paint.

Meticulous cleaning often takes as long as the painting. Be careful not to clean into the edge of the completed renderings. If you do accidentally remove some flesh or hair coloring, go back and reapply it with a finely wrapped toothpick and blend the retouched areas. Rub gently with a clean piece of cotton. Having a cleaned photo will aid you in further color selection and in the examination of your flesh tones. If the skin tones look blotchy at this point, apply another wash of flesh colored paint and wipe with clean cotton. Then reclean the outside areas again. Keep doing this until the skin tone is correct and the background and foreground are clean of unwanted paint.

8. Here, before rendering the background, I clean any unwanted paints from the photograph using a wrapped skewer dipped in extender.

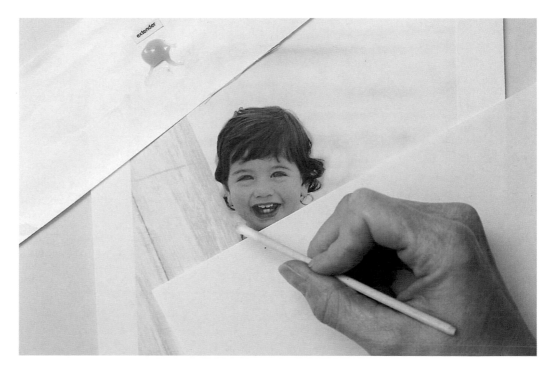

PAINTING IN THE BACKGROUND

When you're ready to begin the background of your picture, give careful thought to the desired overall effect. The background also plays a role in imparting a certain feel to the photopainting and conveying this to the viewer. In my image of Max, the background is made up of areas of sky, ocean, and sand.

A variety of colors are applicable for a sky, so I try to reflect on all the different skies I've observed and decide what would be appropriate here. It could be gray, blue, yellow, red, orange, or any combination of the above. To achieve the overall soft effect that I'm going for in this portrait, and still ensure that the focus will be on Max, I decide to paint the sky a pale blue, the ocean a pale greenish blue, and the sand a pale brownish tan.

Bodies of water present wonderful opportunities for creative use of color. The ocean seems to change color in response to the color of the sky; on a clear blue day, the ocean reflects a strong blue hue, while on stormy days, it reflects the gray of the sky with yellow highlights. Use your imagination when painting water, and work with your photograph, choosing colors that complement the subject and the intended message.

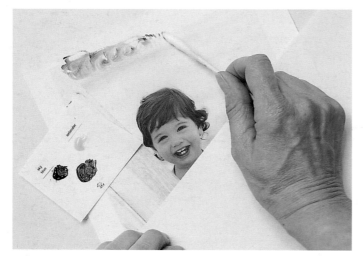

9. To begin, I overload a large wrapped skewer with my sky paint mixture. When painting large areas of the photograph it is best to overload the skewer with paint. Starting at the top left of the image, I cover the sky area with the paint, proceeding across the sky area in a tight circular motion. Once I've covered the sky with little circles, I blend the area with a large piece of cotton, applying firm pressure to achieve a smooth blend; the more pressure, the lighter the sky.

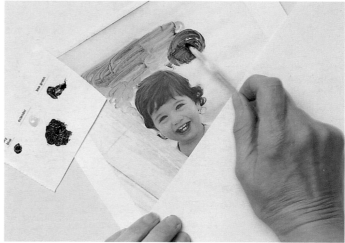

10. For this image, I envision a greenish-blue hue accentuated by highlights of yellow, purple, and blue. I wet a skewer with my ocean blue mixture and apply it in a circular motion to the sea area. After wiping this with a clean piece of cotton, I also use a toothpick to apply yellow, sky blue, and purple hues (all mixed with extender) gingerly and sparingly to the highlights and shadows of the water. I then blend all the colors.

The color of the sand differs considerably depending on the geographic location captured in the photograph. In Westhampton Beach, for example, the sand is light brown. Sometimes, you find a reddish quality. The shadows in the sand reflect the colors of the ocean and sky, as well as of the objects in the photo.

11. Since my goal in this portrait is to focus on Max, I decide on Marshall's Verona brown mixed with extender for the sand. With a wrapped skewer, I apply the sand color in a circular motion, avoiding rubbing into the face, hair, and arms. I also rub down with cotton, going away from these features. (If I accidentally lift painted areas, I go back and fix them. This happens all the time, but I try to prevent it as much as possible.)

To render shadows in the sand, I fill in the shadow areas with sky blue and purple colored pencils. Using sharp pencils for better control, I place the sides of the pencil tips on the photo and push them into the appropriate shadow areas. Then, I rub the color down with a clean wrapped skewer.

COLORING CLOTHING

Just like getting dressed in the morning, you should make sure that the colors you choose for the garments don't clash with one another (or with the background). Clothing colors should also help you convey your intended goal. In my image, the subject is wearing a striped shirt, which I'll render with colored pencils for greater control. To emphasize his babyhood (he's one year old), I use blue for the shirt. For his shorts, a mixture of Marshall's tree green and Verona brown creates a khaki hue. Marshall's own khaki or sepia pigments would also be appropriate.

Before applying any colors to the garments, you should clean the clothes areas with extender to remove all extraneous colors. When you use extender for cleaning purposes, always be sure to wipe all of it off the photo with clean skewers. Colors are difficult to control when applied over excessive layers of extender, and too much extender results in smudging.

12. Using a blue colored pencil, I color in the lines of the shirt as if I were coloring in a coloring book—trying hard not to go out of the lines. I also rub down the pencil with a clean wrapped toothpick to blend the lines.

The trick here is to not go out of the lines, because the blue will then spill over into the white stripes. If this happens, I clean out the white lines with a very fine, tightly wrapped toothpick dipped in extender or color over them with a white pencil.

13. When the shirt is complete, I move down to the shorts. After mixing a khaki color, I apply it using a small, clean wrapped skewer, and then rub over it gently with a piece of cotton.

FINISHING THE PICTURE

Once you've completed the background and clothes, only a few final elements usually remain. In this case, it is a beach bench. For this I will use gray colored pencils, accentuating the shadows with shades of blue and purple. There is a wide variety of gray pencils, so I select a few warm tones and a few cool ones and experiment first, before deciding. Note: To cover a large area with pencils, first cover that area with a light coating of extender and rub it down. This causes the pencils to become creamier and spread more easily over the photo. Once I've painted all the elements, I scrutinize the photopainting, looking for final corrections. I even turn it upside down and see if the colors look right.

14. I take my gray colored pencil, turn the tip to its side, and push it firmly across the bench area. Then I crosshatch to cover the area (see photo at right). To blend and soften the pencil marks, I wipe them with medium firmness using a piece of cotton.

15. Crosshatching is a sketching technique in which you draw a few lines in one direction and then draw over them in the other direction.

SUMMARY OF THE PAINTING PROCESS

The following are the key things to remember when handpainting a photograph. It is always a good idea to review them before beginning a new picture.

1. Apply paint to the photograph by rotating the skewer in a circular motion. This is the best method of coverage with which to achieve minimum streaking.
2. For small areas of detail use wrapped toothpicks as applicators.
3. For large areas of detail use wrapped skewer applicators.
4. Always use *wrapped* skewers and toothpicks; if unwrapped, the sticks will scratch the photograph.
5. Clean areas of unwanted paint from the photograph any time the next, new color is lighter or of the same intensity as the previous colors. When in doubt, clean the area anyway.
6. Use skewers to clean areas of the photograph, in addition to applying paint.
7. Cleaning is a constant and integral part of the painting process.
8. You can cover large or small areas with colored pencils if you don't want to use paint. Turn the pencil tip to its side and push the color onto the surface of the photograph. Then crosshatch and blend.
9. Start light. It is much easier to build color up than to remove color.
10. Turn the picture upside down. Sometimes this inverted perspective helps you see color harmony better. Plus, it aids in painting without smudging previously covered areas.
11. "Listen" to what your picture is telling you visually. Often, a missing color will make its absence felt.

BLENDING PENCILS AND OIL PAINTS

*I*n effect, handpainting a photograph is a multi-media endeavor, often requiring the layering of different mediums over the photograph in order to achieve the intended visual expression. The use of oil paints and pencils in tandem can result in intriguing new effects, including heightened tactile, ethereal, and atmospheric qualities. Painting with pencils is an enjoyable, relaxing process. You can attain many nuances and subtle new shades of color working with this fluid medium. As mentioned previously, you can "paint" whole areas of a photograph with colored pencils, and since the pencils are transparent, layering one colored pencil over another helps create new hues. You can also apply pencils directly over, and blended with, oil paints to add depth to your photograph and detail to any highlights and shadows.

The key to "painting" with colored pencils is a wet paper surface. You can achieve this by either priming your photographic paper with P. M. Solution or turpentine, or by using oil paints or extender as the base lubricant. You can also employ both these methods simultaneously. For example, you could prime your photograph and then apply a wash of oil paint (*don't* rub down the color) as a base coat. You would then use the pencils directly over the oils, as will be demonstrated shortly.

To soften colored pencils for a more fluid application, you can wet the tips of them with P. M. Solution.

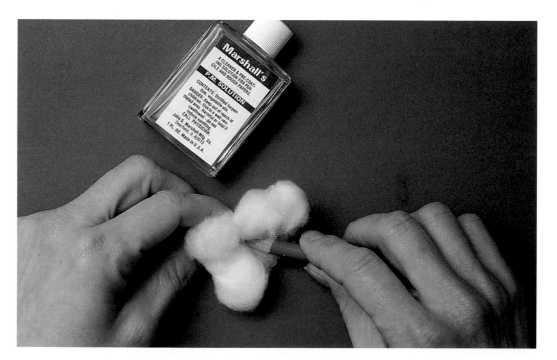

The paper surface affects the process of painting with pencils. A smooth matte surface best camouflages pencil strokes. Textured paper absorbs the pencils, but an extremely wet surface is required to keep the medium fluid and to hide the pencil renderings; some heavily textured papers make this process difficult. One way to work within the confines of textured paper, such as varieties from Portriga, PolyMax, or Luminos, is to prime the paper and leave the primer on (without rubbing as shown on page 74). The wet surface keeps the pencils wet and malleable. Wetting the tips of your pencils with P. M. Solution or turpentine will also help soften them for easier renderings. On the other hand, visible pencil marks may be the look you want. It's best to try different papers and methods of application and see what appeals to you.

MIXING MEDIUMS, STEP BY STEP

To illustrate the handpainting technique of coloring with both pencils and oil paints, I'll use the photograph on page 94, which is printed on Ilford Multigrade IV FB paper. I masked and primed the photo as outlined in chapter 4, and set my palette with flesh tones, greens, earth tones, browns, and blue. If your selection of paints is

This is the palette I used for my photo of Brittany, Chelsea, and Julien on page 97. I organized the colors to encourage the emphasis on green that I wanted to convey in my photopainting. So, the colors for mixing various green hues are placed close together on the palette paper for easy mixing.

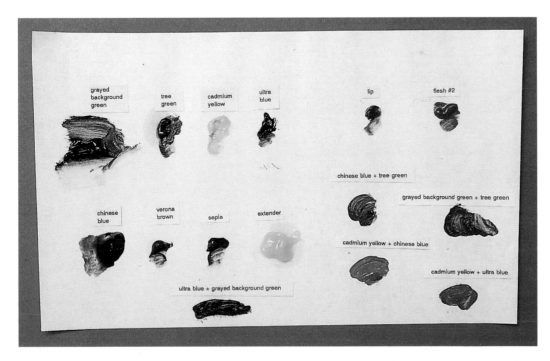

limited, you can easily mix the different shades you need. Mixing your own hues is often a blessing because you can achieve beautiful colors that wouldn't otherwise be attainable. Often, you'll need a few different blues to create a better variety of greens. If you only have Marshall's Chinese blue, consider purchasing ultra blue, as well, to increase your mixing capabilities.

To emphasize the background, which in this photograph is rich in detail, I decided to use colored pencils in combination with oil paints, building color with layers of both mediums. Just as you choose your paint colors before you begin, you should also give some preliminary thought to your selection of pencils. Note that even when using these two mediums together, the basic application process remains the same: skin first, then hair, features, background (from top to bottom), and clothes.

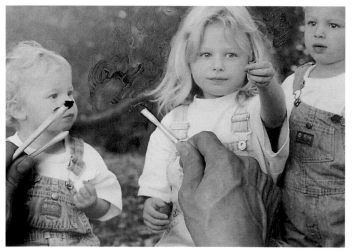

1. After first finishing the flesh tones, I apply a wash of dark green oil paint (Marshall's background gray green plus extender) to the entire foliage background area. I use just a little extender to help move the paint over the surface; too much extender would have created a wash that was too thin and wouldn't have shown on the dark gray values of the picture. To apply this wash, I use a large skewer and apply the paint in a circular motion.

2. Once the wash sets, I introduce additional shades of green and brown, mimicking the wondrous natural display of color in the foliage. Using a new skewer for each color, I add these hues following the photograph's gray tones; so, I apply the darker greens to the darker portions of the photograph and the lighter greens to the highlights.

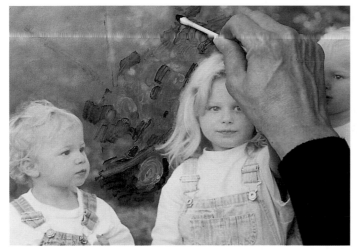

3. Leaving all the paints wet and unblended, I continue to embellish the background with color.

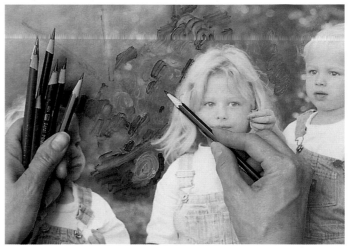

4. Leaving the paint colors wet and unblended, I select colored pencils in olive green, marine green, dark green, dark umber, dark brown, purple, navy blue, and lipstick red and begin to apply them over the paint. Colored pencils work well for building depth in a photopainting, and to do this I place rich dark tones next to highlights to create some visual energy.

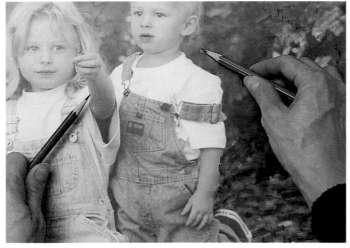

5. I continue applying the colored pencils to build up depth in the image, using the side of the pencil rather than the point.

6. I also utilize complementary colors, in this case orange and blue, to highlight select areas of the image. Here, I've already put down the orange-brown color and add a blue colored pencil next to that. This increases the vibrancy of the leaves, which were illuminated by the setting sun.

7. When I feel that I've added enough color and dimension, I blend it all with clean cotton. Since this photograph is a 20 × 24-inch format, I use large pieces of cotton for blending. I rub lightly so that I don't lift the color but rather just rub it enough to blend. The rubbing and blending allows for the creation of new hues as the paints and pencils mesh. If, while working, you find that you've rubbed down too much and removed too much paint, simply apply more paints and pencils. Painting is a continual process and more than one application of color is often needed.

8. I paint the foreground foliage in the same manner as I did the background, using earth tones to build depth in the ground and bench. I'll paint the clothing last using a blue colored pencil, or a wash of sky or Chinese blue paint plus extender, for all the denim areas. After I've applied the blue, I'll carefully blend the brush or pencil marks with clean cotton or a clean wrapped skewer.

BRITTANY, CHELSEA, AND JULIEN

The finished photopainting doesn't scream color, but rather has a very rich, subtle palette. I added and built up layers of color in a slow, deliberate manner to create atmosphere and a heightened sense of the moment.

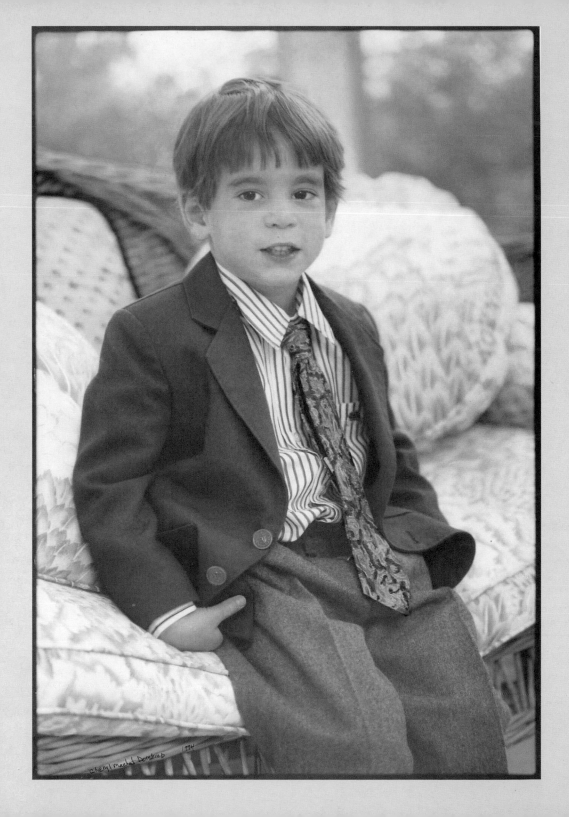

cheryl machat Dorskind 1994

MORE ABOUT PORTRAITURE

As a photographer, you can be defined by the medium, or redefine the medium in terms of your own needs.

—Duane Michals

*M*astering the fundamentals covered in the previous chapters is essential to finding your own visual voice. Moving beyond the basics of paints and pencils, however, sets the stage for a more in-depth exploration of the creative potential of these materials, and also transports you into new realms of creative expression. As the boundaries of photography and painting blur and blend together, handpainting truly becomes an artistic means for revealing a very personal message. My personal artistic expressions and messages often involve portraiture. The challenge in executing a successful handpainted portrait is to convey the essence or spirit of the subject through body language, composition, point of view, background, lighting, and the strategic application of color.

There are several different approaches to portraiture. There's the formal studio portrait, involving artificial studio lighting and posed subjects; the informal portrait, using ambient light and seemingly candid poses; and the environmental portrait, which often shows the sitter in his or her own living or working environment. Typically, I photograph my clients, and their families and children, in settings that are the most familiar, intriguing, or desirable to them. Children, in particular, are more cooperative and natural in their home environments. In running a portrait photography business, I've found that to acquire a respectable client following requires perfection; people want beautiful photopaintings, and in terms of portraiture, they want images complete with accurate facial rendering and hair coloring.

Every face tells a story. People come in all shapes and sizes, and, perhaps most importantly for the handpainter, in all different colorings. Hair color is often the most obvious difference between subjects, and hair coloring in turn can affect the overall cast of a person's complexion. In this chapter, we'll examine some of the basic hair colors and how to best represent them.

JOSH

Muted analogous colors (reds, violets, and blues) set the mood of this portrait. Notice, too, how the pants, which have been left the unpainted gray tone of the photograph, take on a reddish cast due to the tone of the photographic paper and the reflection of the colored areas of the photopainting.

99

REDHEADS

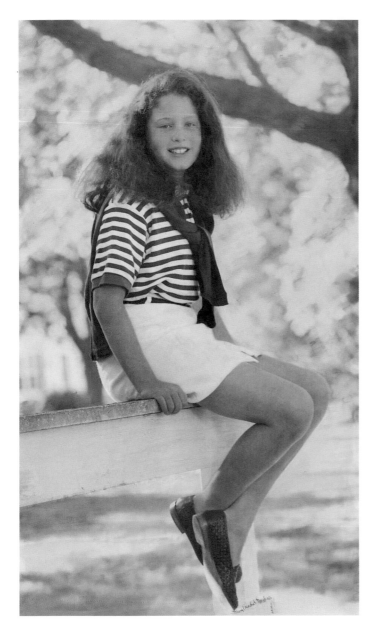

The process of handpainting a redhead provides a lesson in seeing beyond concepts. The subjective and illusive nature of the perception of color challenges you, when selecting a colored pencil or a tube of paint, to match what you see as a "redhead." There are, in fact, many colors that you can use: orange, yellow, brown, red. Their many hues, combined, create red hair coloring. One color alone won't suffice. Attaining the right look requires careful observation, research (study redheads to observe the many nuances of their coloring), understanding your subject (redheads perceive their own hair in different ways), and skillful painting.

The following oil paints and colored pencils are good choices for representing redheads: for Marshall's paints try their cadmium yellow, Verona brown, sepia, and cheek; for Marshall's and Prismacolor pencils try sepia, cadmium orange, cadmium yellow deep, and burnt sienna. You can substitute a dark umber pencil for sepia. The painting process involves layering colors one over another to build up a redhead shade that's rich with highlights and detail. The logic is to start with a dark tone and create the highlights with the more luminous and vibrant colors. The following photographs illustrate the basic formula, which you can easily adjust to suit any redhead.

LISA

Redheads make engaging subjects. Capturing the variety and richness of red hair poses an interesting challenge to the handpainter.

1. First, I put down a layer of Verona brown paint over the entire hair area using a clean wrapped skewer. I've already done this in this photo, using the paint full strength and applying it in a circular motion, rubbing down to blend. This first wash creates the base tone. Then, with a clean skewer, I apply cadmium orange paint over the brown wash in the same manner.

2. To build up the red hair color, I add sepia paint over the Verona brown wash in the shadow areas and apply orange paint (mixed from cadmium yellow and cheek) to create highlights. Using wrapped skewers, I gently rub down the paints to blend the colors. I also reinforce highlights and shadows with cadmium yellow deep, cadmium orange, and sepia colored pencils.

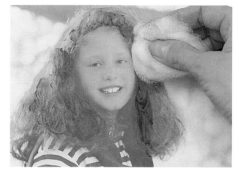

3. Softly grazing the print with cotton, I blend the colors together using a gentle sweeping motion.

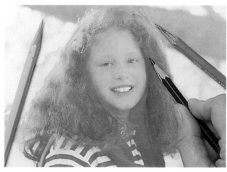

4. To intensify the highlights and shadows, I use colored pencils, which strengthen the painted tones. I apply sepia pencil all over the hair to tone it down, creating a realistic and flattering color. For a more subdued red color, I apply the cadmium orange pencil. I use the cadmium yellow deep pencil in the highlights and the burnt sienna in the shadows as a final touch. To blend them, I gently rub down the pencil renderings with a clean wrapped skewer (for a specific highlight) or a clump of clean cotton (for an overall blend).

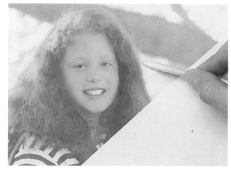

5. At this stage, I like to clean the background of unwanted paint using a wrapped skewer dipped in extender. Doing this gives me a fresh perspective; against a cleaned area, I can better fine-tune the hair coloring. I scrutinize the photo carefully, taking note of which feature draws the most attention. In portraiture, the eyes should, arguably, be the key element; this is, after all, a portrait of a young girl, not just a picture of some red hair. So, if the hair were too vibrant, I would tone it down by wiping it with a clean skewer or piece of cotton.

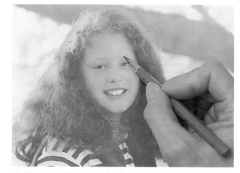

6. For the final touch, I add the eyebrows using the cadmium orange pencil. Eyebrows help frame the face and should be colored to match the hair. When one colored pencil won't suffice, layer one on top of another, just as you would for rendering the hair.

BLONDS

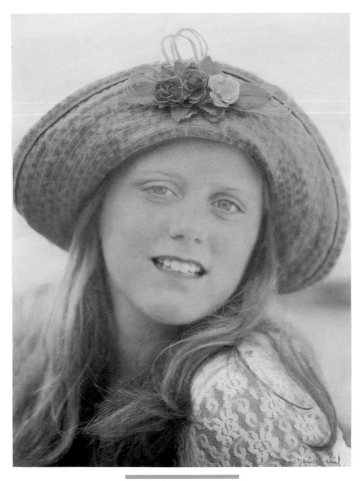

LINDSEY WITH HAT

To reflect Lindsey's passion and sensitivity, I opted to paint the sky a warm hue to balance the cool blue hat that frames her face and accentuates her blue eyes. The cool feel of the blue also sets off the warm yellow tone of her blond hair, bringing it closer to the viewer.

As with painting redheads, simply using one colored pencil won't do justice to the many nuances of blond hair. There are many shades, including ash, strawberry, dark, peroxide, and platinum blond. Using plain yellow to paint this hair color usually produces a garish, unrealistic look. Consider the following basic procedure for representing blonds: Begin by applying a light wash of Marshall's Verona brown paint mixed with extender to create the blond base. Then, rub down this wash and apply a raw umber colored pencil (I used Prismacolor brand here) over the hair. Add sepia pencil to the shadows to create depth, and then gently rub down the pencil renderings with cotton to create a more natural effect. Add a final layer of highlights with the raw umber pencil following the highlights of the photograph.

To achieve a darker blond hair color, use less extender in your base wash. Also apply a dark brown pencil (rather than sepia) to the shadows and the raw umber pencil sparingly to the highlights. For a lighter blond, use a lighter brown base wash and rub down hard on it with cotton. Use light earth tones or yellowish hued pencils, such as goldenrod, yellow ochre, and light umber (these are Prismacolor pencils) to create the correct blond look.

NICOLE

The soft, analogous color scheme of blue, green, and yellow impart a calm, harmonious feel to this image. Plus, the warmth of the subject's blond hair and peachy skin is set off well by the cool feel of the green background and blue denim shirt.

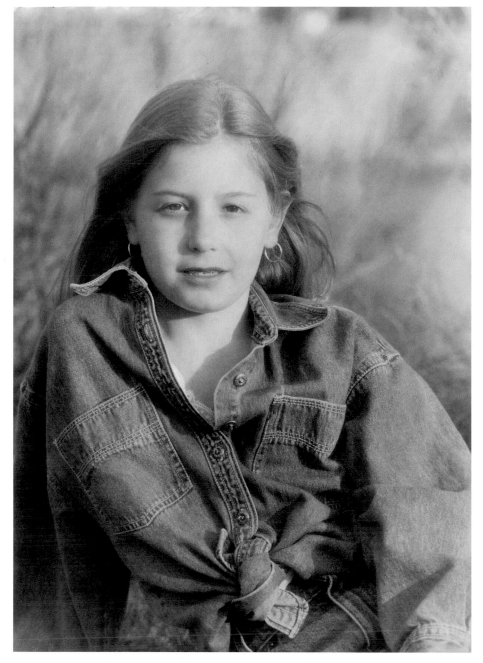

BRUNETTES

*T*he basic formula for creating dark brown hair is black paint mixed with Verona brown and used at full strength (not diluted with extender). Add a little extender to the mix for a slightly lighter brunette color. For medium brown hair, see page 84. Marshall's Verona brown paint has a yellow cast and therefore requires that you mix it with black to achieve a neutral brown hair color. The addition of black pigment adds an element of depth and density that is required for successfully representing dark brown hair.

Use a dark umber or sepia pencil to achieve a reddish glow in the highlights, Verona brown for a yellowish cast, and dark brown for more neutral highlights and more depth to the shadows. For added depth, use black and dark brown pencils in the shadows. As with the red and blond colorings, gently rub the pencil applications with a clean piece of cotton or skewer (for greater control in areas of fine detail) to blend all the pencil renderings. To alter the darkness of brown hair coloring, vary the proportion of black paint in your initial paint mixture.

RABBI MARC
SCHNEIER, TOBY,
AND SLOANE

In this portrait, I emphasized the
luminosity of the subjects' brown
hair with a sepia colored pencil.

For light brown hair, mix Verona brown plus a touch of black plus extender. (Note that you only need a little black to neutralize the yellow tint of the Verona brown pigment.) Add the extender to the paint bit by bit until you reach the desired lightness, and test the mixture first before putting it on the photo. Apply this mixture to the hair and rub it down with cotton; note that rubbing down hard will help you achieve a nice light brown color cast. Add a light brown pencil, such as Verona brown or light umber, to the highlights, and use a dark brown pencil for the shadows.

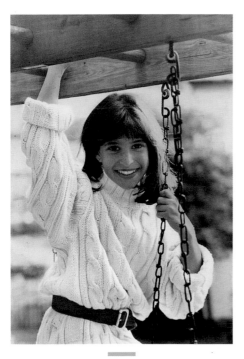

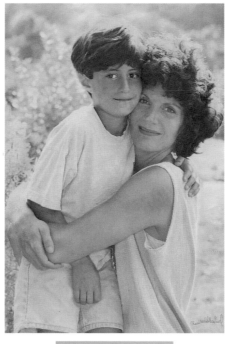

ALIX

To capture the warm feel of the sun, I highlighted Alix's hair with Verona brown pencil, which I rubbed down with cotton to produce a yellow cast. To tone down the teeth, which can sometimes appear too bright against subtle handpainting, I applied a pale wash of color. I used a wrapped toothpick, covering the entire teeth area and then wiping nearly all of the pigment off. Raw sienna paint lightened well with extender is a good color to use for this.

SHARON AND DAVID

Notice the subtle different casts in the hair highlights here. For David's hair, I used Verona brown oil paint and then added a layer of Verona brown colored pencil. This gave it a nice warm cast. For Sharon's hair, which is a little redder in color, I applied a layer of sepia oil paint topped with sepia colored pencil to accentuate the brunette highlights.

BEN

To create a neutral brown hair coloring, I first applied a wash of Verona brown paint mixed with extender for the base, and then colored over the entire area with a dark brown pencil. To blend the two mediums, I rubbed down on the color with a clean wrapped skewer.

GRAY HAIR

*W*hen considering hair colors, don't forget about gray. For attaining a basic gray hue, I mix Marshall's neutral tint paint with extender and apply it as a base covering over the entire hair area. I rub this down to blend, and then add Payne's gray paint to the shadows and yellow or blue pencils (this is really personal preference) to the highlights. Payne's gray has a blue cast, so if necessary, you can neutralize the blue with a touch of black paint.

To emphasize any graying in hair, apply a wash of the subject's original natural color and then clean some lighter areas (as highlights) with extender. The gray tones of the photograph will naturally shine through the color. To subdue the look of graying hair (many people don't like to be reminded of their gray) leave the wash of color intact.

YOSHI HIGA

Due to the overall lack of bright color in this photopainting, the texture of the subject's gray hair really stands out, adding interest without the use of much color and drawing attention to the subject's face.

DIANE VAHRADIAN

To represent graying hair, create a wash of color that best approximates your subject's hair and cover the entire area with it. Diane's natural hair color was black and this is still visible in parts, so I applied a wash of Marshall's neutral tint paint mixed with Payne's gray. This is the basic black hair/gray formula.

ARTISTIC BACKGROUNDS

*T*he background is an integral part of the overall visual statement of a photopainting. The goal is to achieve harmony in your background colors—to create a unified, balanced composition in which the focus and interest remains on the main subject and isn't diminished by competing or distracting backdrop colors. To do this, you can alter the environment at your discretion, and this is one of the treasures of handpainting. You have the creative license to create and manipulate the surroundings. A field of grass doesn't have to be only green; it can possess many hues from brown to gold to crimson. A yellow house can be made brown. A blue sky can be turned pink.

Whether you're sharply altering the background or representing it as it truly appears, always select background colors that create harmony among all the hues and that are consistent with the visual message you're trying to convey. Use your color wheel; it is a great resource! Also, consider the following three approaches to painting backgrounds in portraits: 1) select background colors that contrast in hue with the overall colors of the subject; 2) choose background color values that contrast with the overall tonal scheme of the subject; and 3) select background colors that contrast in temperature with the colors used for the subject.

COMPLEMENTARY COLORS FOR CONTRAST

Colors can complement, accentuate, intensify, or subdue. In the photopainting of Brittany and Alix (opposite), the boldness of the red hair is offset by the equally bold green background. Remember, green is the complement of red, and complementary colors placed next to each other create strong contrast and strong visual impact. Using this strong green hue for the background takes the emphasis off of Brittany alone, allowing the viewer to focus on both children, which was the goal of this portrait. The bright white shirts and blue jeans further balance the composition, encouraging the viewer's eye to move fluidly from one girl to the other. Ironically, the bold colors actually create a quite tranquil effect.

ANALOGOUS COLORS FOR GENTLENESS

Every photograph has a different feel. The photograph of Nicole and Joelle on page 110, for example, conveys a soft moment. Often, an analogous color scheme best captures this feel. Analogous colors are hues that are contiguous on the color wheel and, as a result, can offer a greater amount of color harmony. For my basic analogous scheme in the photopainting of Nicole and Joelle, I chose blue, red-violet

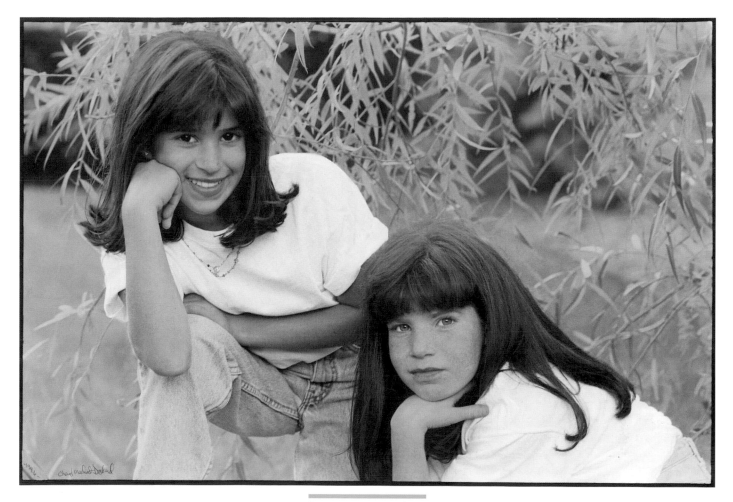

BRITTANY AND ALIX

This painting maximizes the subtle shifts of light and density in the background foliage. Using three different hues of green paint—oxide green, tree green, and background grayed green—I mixed three new shades of green with which to paint the background. Following the gray tones in the actual photograph, I applied the darkest green to the shadow areas (the black areas on the photo), the mid-range green to the majority of the foliage (the mid-gray areas), and light green to the highlights (the lightest gray areas). I placed one shade of green right next to another and then blended them all with several broad sweeps of cotton. This encouraged the greens to blend and create a variety of natural and interesting patterns.

To build additional color intensity, I added a layer of oxide green pencil to the light green areas, and gently blended this to hide the pencil marks. This extra layer of color created even more luminosity.

NICOLE AND JOELLE

The harmonious analogous color scheme complements the tender subject, my daughters Nicole and Joelle. After applying all my colors, I gently blended them all well to achieve a soft overall effect. Note that denim looks great handpainted. Many different blue hues work well, including Chinese blue, sky blue, navy blue, and ultra blue extra strong (these are all Marshall's paint colors).

To create a soft look, like the one here, mix your blues with a high percentage of extender to dilute the color. For heavier paint concentration, apply the color straight from the tube, or use a blue colored pencil to color the jeans. When finished with the color application, rub down on it to blend, but do so softly enough so as not to lift the desired vivid color.

(magenta), and violet (purple), which I used mostly in the background. In this image, the gentle feel of the analogous colors is also accentuated by the tender pose, the diffused backlighting, and the blurred background.

A delicate background is imperative in maintaining the softness of an image like this. To render the background behind Nicole and Joelle, I used a wash of Verona brown. Then, before rubbing down the wash, I applied colored pencils directly onto the wash, which provided enough lubrication so that I was, in fact, *painting* with the pencils. I used blue, brown, magenta, and purple colored pencils in the shadows to add depth to the image. Layers and layers of color can be built up and fine-tuned in this way.

CREATING FIELDS OF GREEN

Green is a tricky color. Its application often separates the novice from the skilled handpainter. When applied on its own over a dark gray photographic tone, the color green yields a realistic rendition. However, when working over a light gray tone, green hues must be mixed with other colors to achieve a flattering interpretation. Often, a mix of paints and colored pencils also provides nice results.

The black-and-white photograph opposite is a good example of a field of grass that registers as a light gray tone. Simply covering this field with a green layer of paint would have yielded a translucent, unrealistic, and unflattering result. To add depth to the light gray area, I layered oil paints and also painted with colored pencils (see the larger image opposite). The layering of paint washes and pencils yields interesting patterns and creates subtle nuances of color just like those seen in a field of grass.

I often overexpose my film in order to create a better flesh tone in my subject and a dreamier overall effect in the photograph. Notice, however, that in doing this I do lose some degree of detail (this is evident in the surrounding background areas).

CODY

To create this grass I used an initial wash of Marshall's tree green, oxide green, and background gray green mixed with extender to cover the grass. I added earth tones of sepia and burnt sienna pencils directly on top of this first wash before blending anything. I also applied navy blue and purple pencils to the shadows, and then blended all the colors together.

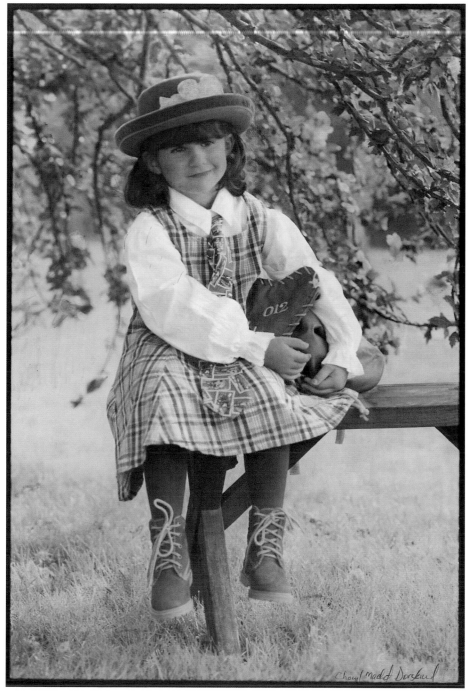

FOCUSING ON THE ENVIRONMENT

Experience and organization are the keys to free expression of color. You select each color to which you have a strong affinity and combine it with others according to logical relationships of harmony until the expressive result is achieved.

—*Nita Leland*

In 1987, I had my first solo exhibition in New York City of 25 landscape photopaintings (many of which appear in this book). The experience of developing this series of images led me to three important discoveries regarding the landscape motif. First, composing a unique photograph is an ongoing quest. Second, selecting a meaningful color scheme requires discipline and forethought. Third, beginning with a high-quality image is essential for creating a successful photopainting.

Beautiful vistas have been photographed over and over since the invention of the camera. While very popular, landscape photography poses many challenges for the photographer. Pushing yourself to find a new angle or new interpretation of your environment so that your art says something new, personal, and perhaps even inspirational is difficult. Avoiding clichéd images is critical to executing a quality photopainting, as is working with a harmonious range of colors that is compatible with your visual message.

In celebrating nature and your environment, you can often be tempted to use too much color. Strive, and struggle, for simplicity in order to make the most of your handpainted landscapes. Many times, an uncomplicated color strategy works best. One method of working that is helpful is to begin with your chosen subject and choose a dominant color that suits the mood you're trying to portray. Pay attention to the lighting in the scene and to the overall ambience. Then, decide on a complete color scheme that best conveys your vision or the spirit of the environment in the photograph.

SIENA, ITALY

The raw sienna hues, accenting earthly elements, capture the rich heritage of an ancient stone building. With vibrant drama, the green shutters framing the long, arching windows both enrich and reflect the Italian countryside.

BASIC LANDSCAPE TECHNIQUES

*H*andpainting affords you the freedom to look at the world and create visual statements using the abstract nature of light, color, pattern, and design. Good photographic composition is critical to conveying those statements. Work with the elements of design, lines, textures, and placement that appear naturally in the environment. Accentuate any eye-catching components in your surroundings by taking the time to previsualize and arrange the image in your viewfinder.

The overall game plan for handpainting a landscape photograph is to start painting at the top of the image and work systematically downward. Remember, the rational here is: 1) to follow the direction of the light, which comes from above and has a significant effect on all the colors; and 2) to avoid smudging paints if your hand were to lean across any painted lower sections of the picture. Revealing the logic within the seemingly spontaneous beauty of the natural world requires forethought, discipline,

AERIAL VIEW

Rather than focusing solely on the ground in this aerial view, I opted to fill half the composition with sky. The cloud formations created a natural, interesting pattern that I knew I could enhance during the painting process.

RAINSTORM

To enhance the dramatic turbulence of this rainstorm, I added very subtle layers of color to the central storm clouds. Knowing when to stop is critical in any photopainting, and every handpainter has a unique way of sensing when a painted image is done. Pay attention to this, and over time, you'll develop your own method of determining when your photopaintings are complete.

and skillful execution. However, there's plenty of room for creative license, especially with color. So, beginning with the sky at the top of a photograph, you would follow the illumination down to the earth, all the while developing a color strategy.

The time of day sets the tone of a photograph. A blue midday sky, a pink sunset, and a gray blanket of twilight all produce distinct spectral effects in the environment. You must incorporate these effects into your color selections to make visual sense of the landscape. A blue sky on a clear day casts a bluish tint throughout the environment, while a sunset casts a warm glow and a dusky gray dulls any atmospheric hues. Additionally, there is the element of blue in all shadows to consider.

Clear days don't necessarily make for the most dramatic illumination in a photograph. Overcast days, however, provide a wonderful, even light for handpainting and create unusually evocative moods. For example, the photo on the next page encompasses strong graphic composition and an analogous color scheme. My decision to purposely limit the palette enhanced the dreamy effect of the fog. The lighting, defined by the

color of the sky (a wash of Marshall's background gray green mixed with extender) is consistent with a foggy day. This subtle green/blue coloring is the dominant color of the entire picture, and the rest of the colors of the palette are equally muted. If I had opted instead for a blue sky, I would have had to commit to more vibrant colors to balance the intensity of the blue, and the mood of the image would have been totally different.

Note that photography flattens perspective, condensing areas that are far away. The landscape handpainter must follow the logic of the environment to keep this two-dimensional quality to a minimum. Taking distance into account, it is often a good idea to paint elements that are farther away using very subtle hues. As the elements of a landscape move toward the foreground (and the viewer), choose more pronounced colors.

FISHING PIER

For this harborscape, I used only the subtlest washes of color to enliven the photographic grays, which helped to convey the naturally misty quality of the scene. The water matches the intensity of the sky, and since water reflects all the colors of the surroundings, I added layers of green, violet, red, and navy colored pencils over the water's base wash of extender, Marshall's background gray green, and ultra blue paints.

I also utilized the interplay of complementary colors with the red of the lobster traps contrasting against the green of the garbage can on the pier. Also, the geometric composition places the pier diagonally across the picture plane, strategically drawing the viewer into the moment and the image.

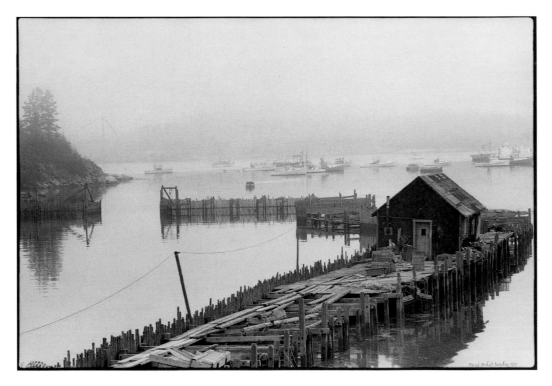

DUNE ROAD
(TWO VERSIONS)

Handpainted over a light photographic print (top), this image suggests a break in the storm. Handpainted over a dark print (bottom) that displays greater contrast, the image displays a heavier atmosphere. The lightness or darkness of a photograph's gray tones affects the applied colors and, consequently, the overall atmosphere of the image. Always keep the gray tones of a photograph in mind as you paint.

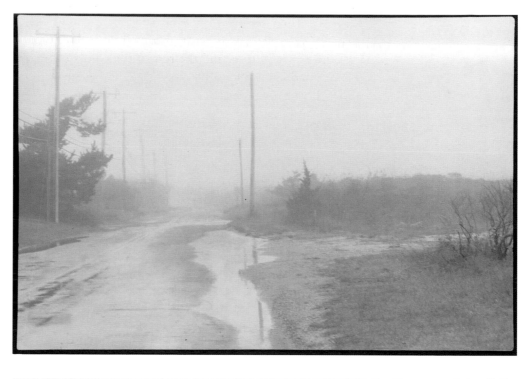

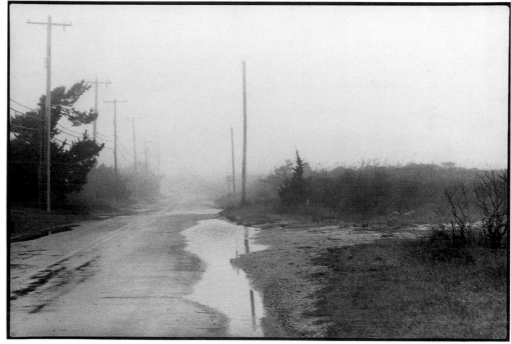

CHOOSING THE RIGHT COLORS

*C*olor is one of the most prominent and expressive components in art. Drawing on memory, personal preference, and symbolic representation, the handpainter strategically manipulates color to navigate a photographic landscape and communicate with the viewer. By employing principles of color theory, visual unity is achieved. Your interpretations of a setting are an integral part of handpainting. You can reveal how you feel about a particular photographed place through the emotional and psychological qualities of color.

The image "Montauk Fences" below utilizes a primary triad color scheme. This is a color scheme whose colors (red, yellow, and blue) form an equilateral triangle on the color wheel. A primary triad utilizes all three primaries in color mixing, from which the all the secondary and tertiary hues are mixed. The three prominent hues in

MONTAUK FENCES

The art of handpainting isn't mechanical. It is instinctual, and requires an instinctual approach in order to feel your way through the narrative. Color theory can help you attain color balance once you have decided on your color game plan. Much contemplation and experimentation surrounded the painting of this image. I started with a deep blue sky, which felt too much like "heaven" and would have required the use of other intense colors to achieve picture unity. Since I wanted this picture to be about peacefulness, I pared down the color, making it softer and more subtle until I had created a sense of calm.

"Montauk Fences" are tan, brown, and greenish blue, which all contain red, yellow, and blue in their compositions.

To create this look I applied a light wash of background gray green paint and extender to the sky. I accentuated the clouds with purple, blue, and yellow pencils. For the sand, I used a wash of sepia paint and extender, and layered violet, blue, green, and yellow pencils over this to add dimension. I enhanced the tire tracks with violet and navy pencils, hues that mimic those found in shadows on overcast days. For the slats in the wooden fence I used a flesh tone pencil as a base color, which I then emphasized with overlays of yellow (for the highlights), sepia, purple, and navy (for the shadows) pencils. The beach grass was enhanced with oxide green and flesh colored pencils.

BAYCREST

A stronger use of color helps to make this composition more dramatic. The dark brown tree to the right helps frame the picture and creates some vertical direction, while the wooden fence and the background trees provide the depth, as foreground and background elements, respectively. To balance the strength of the foreground tree's color, the warm brown of the fence and the green of all the background trees are also intense in color. Note that the elements in the furthermost plane tend to recede, maintaining the three-dimensional aspect of the landscape.

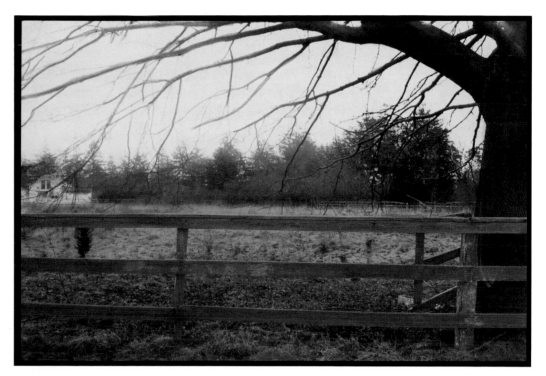

CENTRAL PARK

Photographs such as this one, with large amounts of detail, can be difficult for beginners to handpaint, but the results are certainly worth the effort. It is a time-consuming endeavor, because each petal requires delicate rendering. Blending is also tricky; finding just the right touch takes experience. To begin, I covered the sky area with a wash of sky blue and extender. Before proceeding, I rubbed this down with cotton. In an image like this, the blue paint inevitably seeps over the blossoms, but violet colored pencil covers this beautifully. Sometimes it is prudent to let the sky color dry for two to three hours before applying the tiny foliage details. The final result juxtaposes the sturdy tree trunk and the dainty foliage and fence elements.

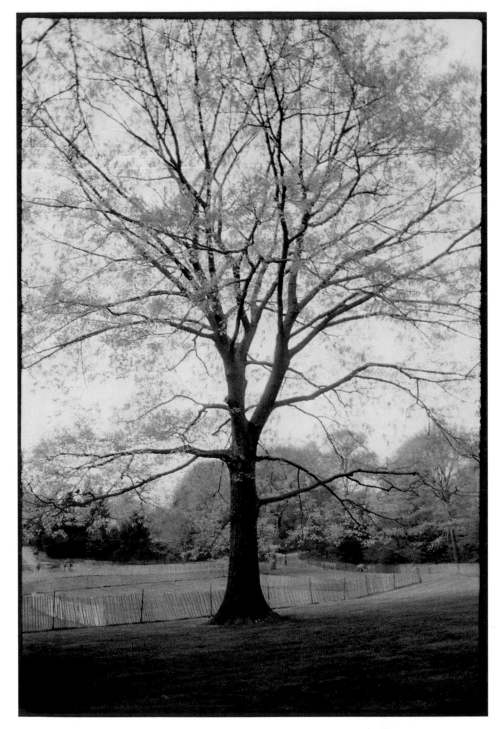

COMPOSITION IS CRITICAL

*W*ithout a person as the subject, a landscape image relies on careful composition for success. To create a successful photopainting, the photograph must be worthy of the paint. Good composition is what made "Spring" (opposite) a compelling image for me to handpaint. The budding cherry tree shapes the picture frame, embodying springtime in New York City. The graphic contour of the distant shadows and the winding picket fence strengthen the composition. Though this image celebrates nature, I limited my palette to an analogous color scheme of green, blue, violet, and brown. Within these color categories I then developed various shades to create a rich and poetic landscape.

Notice, too, how the position of the fences in "Montauk Fences" (page 118) provides a bold, graphic element that enhances the composition and complements the muted color scheme. Stronger colors would have detracted from the interest and motion that the fences add to the photograph.

SUBWAY RIDER

The subway poles are an integral part of the composition of this image. The diagonal pole on the left is especially important as it draws the viewer into the image. Also, the bluriness of the photograph creates a low-key, spooky, almost surreal atmosphere. The colors are very subtle, allowing the underlying gray tones of the print to carry the scene.

PAYING ATTENTION TO PATTERN

Interesting patterns occur spontaneously in nature. It is your task as a handpainter to see these relationships and capture them in your photographs in new and unexpected ways. Patterns are decorative design elements that help structure a photograph. Lines, shapes, values, texture, and color all can create patterns, and patterns, in turn, create visual unity and harmony. They make sense and impose order in an image.

It can be a challenge, at first, to break down the world in your mind so that you see your environment simply in terms of its repetitive shapes. Composing your images to highlight the patterns in cobalt blue skyscraper windows, lines of olive green weeping willow trees, crimson-orange leaves reflected on a pond, or fields of purple dwarf lilies bending in the wind requires a combination of insight, foresight, strategic lighting, selective viewpoint, and color sense.

Painting is often compared to music, and it may be helpful to keep this in mind. The notes that form a melody are similar to the elements that make up a visual pattern. Both are repetitive structural components that add rhythm and design to a composition, be it a musical or visual one. In this sense, then, the function of patterns

BARN

This touch of Americana offered a number of interesting patterns and textures. There is the repetition of the rectangular sign shapes, the pattern of the vertical slats of wood on the barn wall, the slats in the picket fence, and the dense texture of the foliage. All these elements in combination make for a visually rich image.

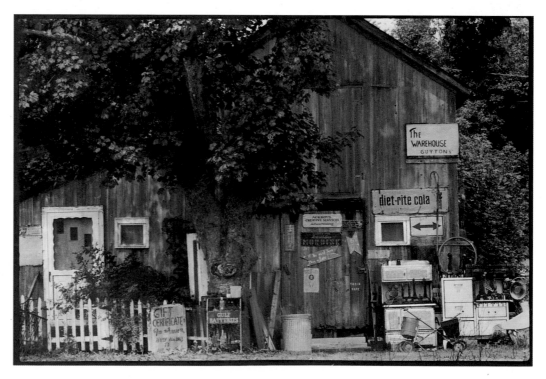

THREE DUCKS

The patterns in this image are subtle but powerful nonetheless. The ripples in the water bring and hold the focus on the ducks, and the repeated pattern of the reeds surrounding them further frames the subject. There is also a very delicate pattern in the foreground, formed by underwater plants, and this further adds to the texture of the composition.

in a photopainting is to create movement and direction, in a rhythmic manner, across the otherwise static picture area. Patterns can be subtle or obvious, exact duplications of each other or only approximate likenesses.

You can focus on the specific, for example cropping in tightly on a tree to reveal the patterns and textures of its leaves, or concentrate on the lines of a wider vista, such as an entire orchard of blossoming apples. Strategic color selection further enhances the patterns of nature. Where the viewer's eye pauses and focuses is manipulated by color. And, as in musical compositions, you can use bold color accents (fortissimo) or soft muted hues (pianissimo).

URBAN LANDSCAPES

YAKITORI MAN

For this urban landscape, I heightened the New York City setting with warm, vibrant colors to suggest the passion and spirit of Manhattan. Notice how close I came in to my subject, echoing the crowded feeling you often experience in New York.

*T*he term *landscape* encompasses country, sea, and cityscapes. Urban landscapes are cityscapes in which architectural images focus on and celebrate form with line, shape, value, and texture. The urban landscape is bursting with visual motifs awaiting realization by the handpainter. The challenge is to find new angles and interpretations, using color, composition, and lighting to capture and describe the spirit of the locale.

When photographing, decide what it is that defines a particular location and what first moved you about that spot. Is it the juxtaposition of the modern with the ancient? Is it a certain tactile presence or the overpowering weight of concrete? Concentrate on the one discerning element that defines the atmosphere of the area. In the case of "Wall, Siena, Italy" (opposite) my focus is on the old stone. This is appropriate since Siena is one of the oldest Medieval towns in Tuscany. The composition utilizes the abstract nature of shadows, drawing in the viewer, and the white string leads the eye across the picture plane.

In general, you should avoid the obvious in your urban landscapes. Unearth the natural rhythms of the scene by depicting comparisons and showing contrasts, such as old versus new. Graffiti, windows, doors, and clotheslines can all embellish your photographs. Experiment with viewpoint and consider trees, archways, and even heavy machinery when framing your image. Concentrate on lighting to add texture to an otherwise monotonous mass. Work with value and let shadows define the space. Find graphic patterns that exist naturally in architecture. Explore the drama of a silhouette or blurred motion. If the photograph works, you'll hear the roar of traffic, feel the wealth, empathize with the impoverished, sense the history, and experience the beauty.

WALL, SIENA, ITALY

The color scheme is basically monochromatic (shades of red over a base wash of Marshall's orchid paint), but the photograph achieves its tactile effect with the combination of mediums—paints and colored pencils. I also built up the feeling of depth by adding color to the shadows, as well as to the highlights.

PRESENTING YOUR ARTWORK

A photograph changes according to the context in which it is seen. . . .
Photographs will seem different on a contact sheet, in a gallery, in a
political demonstration, in a police file, in a photographic magazine, in
a general news magazine, in a book, on a living-room wall. . . .

—Susan Sontag

ZACH AND
JESSICA

Creating a truly successful photopainting is a time-consuming process that requires a great deal of effort. A beautiful image deserves to be well presented so that it looks its best and also endures over time.

*P*eople use photographs in different manners. Some enjoy actually holding the photographs without the obstruction of glass. Others like to see photographs displayed on walls. Final presentation depends on the intended use of the images. My photopaintings are typically displayed in galleries or in people's homes, so I maintain an awareness of a photo's presentation during the entire working process. I try to understand how the client wishes to view the work. I consider whether the image is for an office, family room, or mantle, and whether it will be hung vertically or horizontally.

I usually present my images within a museum-quality white window mat that is two to three inches wide on each side. For backing I use either a piece of four-ply board or acid-free foam core to ensure rigid support of the print. To cover the print, I prefer "non-glare" glass, which prevents unwelcome reflections. Both regular and non-glare glass protect the image from ultraviolet light rays and are 43 percent more effective than nothing. I feel that my choice of presentation materials reflects the quality and care that I put into each project, and invokes the integrity that I seek to maintain.

If I'm framing pieces for museums or gallery shows, I typically use thin, metal frames. This allows the viewer's eye to flow easily from one photograph to the next without dominating the viewer's attention. Frames for specific clients, however, can be more ornate. The frame becomes a decorative piece that complements, and coordinates with, the art and the ambience of the area in which the photopainting will be displayed. The frame can also direct attention to key elements in a composition by use of color coordination, texture, and size. It becomes an intricate part of the art. However, the frame should never overpower the artwork.

ARCHIVAL STORAGE

There are three different avenues for presenting and preserving a completed photopainting: archival storage, matting, and framing. Archival storage systems are designed to protect photographs from the aging processes (especially discoloration) caused by time and environmental elements. Stored improperly, photographs may curl, tear, crumble, fade, or experience discoloration. Archival storage systems are available in various price ranges and styles, including storage boxes, photo albums, and portfolios. You can purchase them at specialty photography shops and mail order companies. (See Resources.) I store my prints in various styles of boxes. Any works that I intend to share with clients, I mat and present in the appropriate size "portfolio" boxes. I store images that I want to keep on file and unmatted in flat storage boxes, like those below.

If not stored properly, photographs will curl, become discolored, and even fall apart. To flatten curled pictures, place them under a heavy book.

These black and burgundy boxes are used for portfolios and presentations. They're available in a variety of colors and sizes. While not for presentations, the manila boxes are economical and perfect for storage. (See Resources for suppliers.)

MATTING AND FRAMING PRINTS

*M*atting is an effective way to display and store your photographic prints. Matted works make a strong visual presentation; acting as a containing border, the mat adds a professional touch that highlights the work at hand. Additionally, matting protects prints from excessive or improper handling. How often have you seen people hold up photographs with their thumbs planted squarely in the middle of the prints? Matting enables you to avoid this. Plus, the mat protects the framed print from otherwise being placed directly against any covering glass. This is beneficial because when glass is placed directly on a photograph, there's no room for air cirulation. As a result, moisture builds up and this moisture eventually damages the photograph.

A mat is generally two boards hinged together. The front or top board has a window through which the photograph is displayed, and the back board protects the photograph from damage. There are many different styles and colors of mat boards available. You can either purchase precut mats (conservation or museum-quality boards are best to preserve your work), handcut your own, or work with a professional framer to create the appropriate mats.

When deciding on the correct mat size for an image, the rule of thumb is to go up one size for the mat. For example, if you have an 8×10-inch print you would purchase an 11×14-inch mat. Note that storage boxes conform to the range of standard mat sizes, which are 5×7, 8×10, 11×14, 16×20, 20×24, and 24×30 inches. When working with a custom framer for exhibition or wall display, you can have your mats tailor cut to suit the individual size of each photograph and the intended display wall or area. Typically, mats are at least two inches wide; two and a half to three-inch mats are the widths most commonly recommended by custom framers.

I recommend matting your photopaintings with white mat boards of either conservation or museum grade. As explained in the Light Impressions archival supplies mail order catalogue (see Resources), "A true conservation mat is designed to enhance the longevity of a print and must not contain any chemical impurities that will contaminate the paper or the emulsion of the photograph. Only certain materials and specific methods of construction completely protect the image from chemical and physical deterioration." Conservation-grade boards are an economical choice. They're acid free and have proven stable over time. Museum-grade boards, with similar archival qualities and a softer, velvety finish, are the high end of mat boards and appeal to discriminating photographers and collectors. A clean, white mat presents the painted photograph in a neutral but enhanced setting.

Mats usually have two components: the supporting back board and the covering top board with a window for the picture. You can hinge the window board to the back board using Firmoplast, which is a heavy-duty, acid-free tape that is strong enough to hold the boards. You can attach the photograph to the underside of the window board at the top of the picture using acid-free linen tape, or you can attach it at the corners of the picture using acid-free corners. If you're using acid-free corners, attach the corners to the underside of the window board (at the corners of the window) using the acid-free linen tape, and then tuck the corners of the photograph into the corners.

In a style consistent with the archival philosophy, the window mat is hinged to a backing mat with an acid-free tape, such as Firmoplast. I prefer using acid-free foam core, rather than mat board, as a backing for photographs that will be hand held and viewed often. The rigid nature of foam core protects against mishandling. To attach the photographs to the foam core (or mat backing), I use acid-free picture corners, which prevent the prints from coming into direct contact with adhesives.

To cut mat boards, you'll need a mat cutter, and there are many styles available. You can purchase a small hand-held cutter or a larger piece of equipment. Mat cutting requires patience and a steady, exact hand. The advantage to cutting your own boards is that you can customize the size of your window openings to accommodate cropped images. It is also economical to cut your own if you plan on using many mats. The disadvantages, however, are the time spent in cutting the mats, the initial costs incurred in purchasing the necessary supplies, and the time and materials involved in mastering the process. There are also some kits available for cutting your own mats. They provide you with a hand-held mat cutter, a straight edge, linen tape, and positioning clamps.

There are many framing possibilities, including ready-made and custom frames, with a myriad of choices in both these categories. You should always select a frame that enhances the photopainting without competing for the viewer's attention. Images

to be hung in groups are often framed in a similar style. In addition, to keep the focus on the artwork, images intended for exhibition are generally framed in a simpler manner than those hung in a private home.

To get an idea of which frames work best aesthetically, notice the frames the next time you view an art or photography exhibition. Study the framing in home decorating magazines, and observe how friends and family display pictures, as well. The final presentation is an integral part of a photopainting. How an image is displayed affects its power and how it is perceived.

Handcutting my own mat boards (with mat cutting tools like those pictured here) was an economical necessity when I began my career. I was able to substantially reduce the costs involved in exhibiting and presenting my work by doing my own matting and framing.

The choice of frames is a personal one. There is an enormous variety of styles and price ranges available. As a word of caution, however, always keep your frames simple so that the focus remains on your photopaintings.

SIGNING YOUR HANDPAINTED PHOTOGRAPH

*J*ust like matting and framing, the artist's signature is an element of the final presentation that also deserves reflection. A signature says something about the personality of the artist and, perhaps, something about the work being signed, as well. The signature completes the project and conveys an air of self-respect, pride, and professionalism. I recommend that you avoid placing your signature on the mat board, because the art must then always be contained in the mat to seem authentic. Instead, sign the photograph itself.

Some photographers sign within the photograph, others sign in the white borders of the print, and others sign the back of the print. I've seen some photographers use a raised seal as a signature and stamp of authenticity, and I've also seen symbols or abbreviations used in a decorative manner. It is up to you. Some photographers also date their work. Dating a handpainting has both pros and cons. On the positive side, it documents the date of completion, enabling you to keep a chronological record of your work both for yourself and for collectors. On the negative side, it dates the image. An image that is thought of as old will seem passé to potential clients and exhibitors. To remain contemporary, it might be worthwhile to keep the dates private.

I recommend signing your name with an archival (lasting) medium, such as oil paints or oil pencils. It can be interesting to sign your name with paint and a brush. I don't suggest using markers because they may bleed through the fiber of the photographic paper. I use a Marshall's photo oil pencil, typically in navy blue, and I sign my work on the bottom right or left corner. I print my name small and include the date on all portrait and landscape images. Study how other artists and photographers sign their works, and find a style that best suits your personality and work.

JOELLE

For this image, my signature fit perfectly in the small space between the edge of Joelle's dress and the end of the picture window. It is legible, yet doesn't detract from the subject.

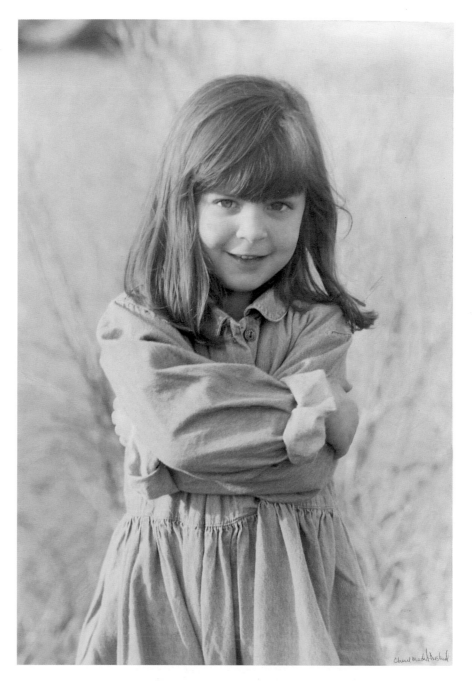

Cheryl Machod-Derskino

SPECIAL ASSIGNMENTS

We shall not cease from exploration
And the end of all our exploring
Will be to arrive where we started
And know the place for the first time

—*T. S. Eliot*

After studying the world of handpainted photography, you'll eventually be ready to explore your environment and identify potential photopaintings. One way to challenge and stimulate your creative energy is to visit a museum and study your favorite artist's use of color and light. Observe shadows and highlights, and take note of the hues that define the work. Familiarize yourself with photography. Discover the photographers who move you. Try to determine why they do. Look at their use of light and color (or value). Study their compositions. If you don't have easy access to a museum, go to the local library or book store. Study advertising campaigns in magazines and photojournalism in newspapers.

We live in a visual world—art and reproductions of art are everywhere. The cinema also offers an entertaining method of studying photography. Analyze the lighting techniques and cinematography, especially the composition and "cropping" of images. Observe the use of backlighting, blurred backgrounds, and color. The basic principles of color theory are often utilized in film, frame by frame, to enhance the director's visual message.

Artists who have inspired my work, and whom I recommend you study, are Edward Hopper, Milton Avery, Amedeo Modigliani, Rembrandt, Henri Matisse, Vincent van Gogh, Alex Katz, Georgia O'Keefe, Alice Neel, and Jamie Wyeth for starters. You should also familiarize yourself with the work of Ansel Adams, John Sexton, Henri Cartier Bresson, Alfred Stieglitz, Richard Avedon, Harry Callahan, Margaret Bourke White, Edward Weston, Dorothea Lange, Julia Margaret Cameron, Bernice Abbott, Imogen Cunningham, Elliott Erwitt, Paul Strand, Walker Evans, Chuck Close, Joel Meyrowitz, Sam Abel, and Nicolas Nixon.

GLENN WITH HIS GREAT AUNTS

As both a photographer and also a handpainter, I always try to see the photographic opportunities around me. Three years ago, my husband Glenn and I visited his old great aunts. While there, I spontaneously photographed him resting beneath his lineage. To highlight the vintage quality of the photograph of his aunts within my photograph, I painted over that photograph with a wash of sepia paint.

EXPLORE YOUR EVERYDAY WORLD

Using tungsten film outdoors without a color correction filter results in a blue cast that creates an interesting mood. Like the other images on this and the next page, I took this photograph on 63rd Street in New York City.

*A*lways challenge yourself to explore your immediate world and see it with fresh eyes and a new perspective. Think about your life, your family, and your surroundings, and determine what moves you and is special to you. A person, a location, or even an object may inspire you. Find that source of inspiration, and photograph it for handpainting. Work with imagery at different times of the day and at different angles until you've translated your feelings and your vision into a photograph.

Many artists worked within the confines of their immediate surroundings. Vincent van Gogh, Milton Avery, Sally Mann, and

FIVE EAST 63RD STREET (TWO VERSIONS)

You don't have to travel to exotic locales to find interesting subjects and composition. I executed both this pastel sketch and the black-and-white photograph at far right looking out a window in New York City.

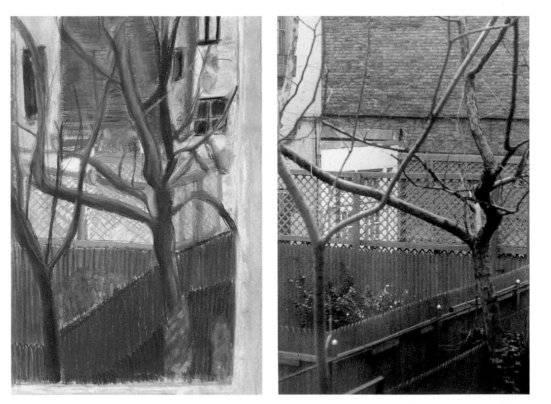

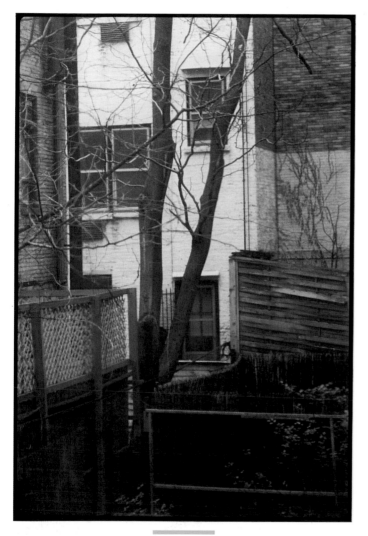

FIVE EAST
63RD STREET

The final handpainted version of this image makes use of interesting composition and conveys a still, somber mood. If you explore your surrounding environment, you will find appealing images.

Harry Callahan immediately come to mind. Van Gogh painted peasant neighbors and the places in which he lived. Milton Avery's repertoire included his own living room, New York City's Central Park, his family, and vacation locales. Harry Callahan photographs his wife and his neighborhood, while Sally Mann photographs her children. Following the lead of these artists, you, too, can aspire to create from your own backyard. The goal is to expose yourself to the magic of the seemingly ordinary, to know your world in a novel, refreshing light, and to articulate this vision through the medium of handpainting.

Much of my work is predicated on this philosophy. Currently, I'm involved in creating a series of self-portraits, but even 15 years ago, I struggled to communicate by using my environment as metaphor. I lived in a charming brownstone in New York City, just off Fifth Avenue, and my railroad apartment was more like one big room. The kitchen, merely a hallway, overlooked a courtyard where a patch of everchanging sky and one maple tree colored my view. I was enchanted with this scene, wondering who lived across the way, and watching as time passed by. I hired a carpenter to build a counter at which I could sit and reflect over coffee as I watched the morning rise and the day ebb.

This view was my source of inspiration. Struggling to translate the magic of the place into a visual format, I tried to draw, paint, and photograph its essence. I was obsessed with it and was unsatisfied with my efforts for years. It wasn't until I moved to another part of Manhattan, that I was able to express my feelings about that special place in a handpainted photograph.

HANDPAINTING VINTAGE PHOTOGRAPHS

CHARLES FRIEDMAN

The regal pose and warm background color emphasize Grandpa Charlie's passion for life.

*T*his project requires bringing family memorabilia out of the attic and into the forefront of your mind. A handpainted vintage picture permanently preserves your memories. Select vintage family photographs (either color or black and white) following the basic guidelines for selecting a photograph for handpainting; look for images with good composition and an emotional hook.

You can convert color negatives directly onto black-and-white photographic paper using Panalure Select RC paper by Kodak. However, the paper is glossy and will be difficult to handpaint. Your best bet is to choose an image and have your local photo lab make a 4 × 5-inch black-and-white copy negative. From this black-and-white negative you'll be able to print any size black-and-white print on any type of photographic paper. Even if the photograph is black and white, always make a black-and-white copy negative of the image rather than painting on the original photo. The large (4 × 5-inch) negative is useful for any size enlargement. Don't worry about faded images; instead, use the imperfections of old photographs as design elements in your handpainting.

When working with vintage photographs, I search through hundreds of pictures before deciding which one to use. With the photo opposite, my goal was to create a handpainted image of my heritage that I could display in my home and one day give as a gift to my children. I chose an image that was highly personal in nature and that had a good sense of design. Previsualization enabled me to look at the wrinkled, faded picture and see its handpainted potential. To capture a feeling of nostalgia without using a vintage photograph, as in the photopainting of Glenn with his aunts (on page 134), I incorporated the past with the present by photographing my husband next to a vintage photo.

ROSE AND CHERYL MACHAT
WITH MARTHA AND
CHARLES FRIEDMAN

As I painted my jacket red, I could remember standing in the backyard, cold and anxious to get the picture-taking over with. The original vintage image itself was fading as indicated by the blurred mass on the right, but I simply used this as a design element and painted it as a shrub.

MARTIN MACHAT

To create this photopainting, I chose colors that were significant in some way and representative of my father's persona. His office had salmon-colored walls, and he often wore a blue shirt.

ROSLYN MACHAT

This image was taken with a Minox camera. Coined in the 1960s as the "spy camera," it was small enough to conceal in a shirt pocket. The negatives were approximately one third the size of a 35mm negative; therefore, the grain size was a factor in this family memorabilia image. Nevertheless, the grain enhances the feel of the past, working well with this particular genre.

HOPSCOTCH

While building up depth in the cement in this photograph, I reminisced over one of my favorite childhood pastimes— hopscotch! Even though this is an old photograph, the bold hopscotch lines, combined with my pose, make for an interesting, almost contemporary composition.

A FINAL WORD

*H*andpainting photographs is a process of discipline, craft, and vision. Finding your own voice takes time and consistent practice. A successful photopainting is dependent upon having a good quality image, good color aesthetics, and mental prowess. Practice previsualization, study art, learn to take great photographs, and look beyond the clichéd image. Expand your own knowledge by observing the environment more keenly. Learn to look and see the details. Take note of the colors that are reflected through the window onto your bedroom walls. Look at a tree trunk and describe all the colors of the bark—they're not only browns. Dive into your world, find your inspiration, and then immerse yourself in your muse.

As you learn the many nuances of the art of handpainting, use this book as a reference. As you master the craft, your vision will undoubtedly increase. As it does, your choices of subject matter, film, lighting, and paper, along with your style of handpainting, will also evolve. These things are all connected, though not necessarily in a linear way. When I was younger, I knew in my heart that I wanted to be a photographer but was paralyzed by my fear of failing, both financially and artistically. Unable to articulate my feelings, I photographed random moments, but over time a common thread began to emerge that inspired my desire to handpaint. Handpainting truly became a way to share my heart and mind.

READING

I overexposed this black-and-white print of a vintage photograph. The result, similar to an infrared photo in terms of luminosity, was the appearance of a little more light and detail in the shrub. Through the use of old photographs I find that I'm able to express my childhood memories with affection, using the art of handpainting to convey my feelings to the viewer.

RESOURCES

Adorama
42 West 18th Street
New York, NY 10011
ph: (212) 741-0052
toll free: (800) 223-2500
This camera and photography supply store stocks Marshall's Photo Oils and colored pencils, along with film, developing chemicals, photographic paper, and spot toner. Also offers mail order service.

A. I. Friedman
44 West 18th Street
New York, NY 10011
ph: (212) 243-9000
toll free: (800) 736-567
Offers studio furniture; combination lamps; po matting, and framing Marshall's Photo Oils spotting agents; pai colored pencils; an

Amazon Book
website: www
This on-line b resource. Se title or sub function e out of pr reviews of eac

B & H Photo
420 9th Avenue
New York, NY 10011
ph: (212) 444-6600
toll free: (800) 947-9970
website:
www.bhphotovideo.com
Known for its discount prices, B & H services customers

nationwi
York Cit
order,
photo
supp
Oils
re
a

Dick Blick Art Materials
P. O. Box 1267
Galesburg, IL 61402-1267
ph: (800) 447-8192
duct information:
...42.
*...ail that
...etail
...talogue
...ns. Sells
...g materials
...as ready-
cut mats,
ation lamps,
Oils, colored
.ch more.*

...essions
...e Avenue
...940
...r, NY 14603-0940
...0) 828-6216
...00) 828-5539
*...vn as a leader in photo
...ival products. Carries a full
...ay of presentation materials,
...ortfolio boxes, framing supplies,
mats, art books, Marshall's
Photo Oils and Photo Pencils,
paintbrushes, and retouching
dyes. Call for a catalogue.*

**The Maine Photographic
Resource**
Two Central Street
P. O. Box 200
Rockport, ME 04856
ph: (207) 236-4788
toll free: (800) 227-1541
*Sells film, photographic paper,
retouching kits, Marshall's Photo
Oils and Photo Pencil kits,
portfolio boxes, and books.*

**New York Central Art
Supply**
62 Third Avenue
New York, NY 10003
ph: (212) 473-7705
to order: (800) 950-6111
*A well-established art supply
store that carries Marshall's
Photo Oils (in sets and by
individual tubes), skewers,
colored pencils, spotting agents,
matting and framing supplies,
and combination lamps.*

Pearl Paint
308 Canal Street
New York, NY 10013
ph: (212) 431-7932
toll free: (800) 221-6845
*A large and well-known art
supply company, Pearl has 19
outlets nationwide, including
locations in Chicago, Houston,
Tampa, Miami, Philadelphia,
San Francisco, and Los Angeles.
Call for a catalogue and list of
stores. Sells all sorts of supplies,
including Marshall's Photo Oils
in sets and individual tubes,
paintbrushes, colored pencils,
matting and framing materials
(both custom- and ready-made).*

Texas Art Supply Company
2001 Montrose Boulevard
Houston, TX 77006
ph: (713) 526-5221
*Stocks Marshall's Photo Oils
paints.*

*local cra...
stores, andpliers,
may also stock t...
Stores that carry Marshall's
Photo Oils typically stock
skewers, as well.*

INDEX